Postcard History Series

Manchester

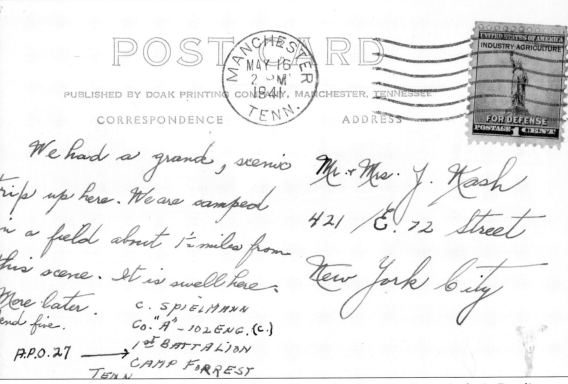

Shown above is the back of the postcard that a soldier stationed at Camp Forrest in the 1st Battalion, C. Spiemann, chose to send to Mr. and Mrs. J. Kash in New York City, postmarked May 16, 1941. His message that the town is "swell here" gives the Kash family a favorable impression of the Manchester area. (Authors' collection.)

ON THE FRONT COVER: In this postcard, a soldier is shown directing traffic as motorists travel on Highway 41 along the south side of the square. Note that the movie *Road to Zanzibar* (1941) was playing at the Lyric Theatre. It starred Bing Crosby, Bob Hope, and Dorothy Lamour. To the left of the theater entrance is Bob's Place, and to the right is the Peoples Bank and Trust building. (Authors' collection.)

ON THE BACK COVER: This postcard, photographed by Hugh Doak, shows Highway 41 in the early 1940s as it cuts through the hill almost 10 miles northwest of Manchester in the Noah community. Motorists headed south would have the treacherous trip up Monteagle Mountain just over 35 miles ahead. Those headed north would arrive in Nashville about 55 miles ahead. (Authors' collection.)

POSTCARD HISTORY SERIES

Manchester

Jane Banks Campbell and Lori Jill Smith
Foreword by Weldon Payne

ARCADIA
PUBLISHING

Published by Arcadia Publishing
Charleston, South Carolina

Printed in the United States of America

Library of Congress Control Number: 2013938522

For all general information contact Arcadia Publishing at:
Telephone 843-853-2070
Fax 843-853-0044
E-mail sales@arcadiapublishing.com
For customer service and orders:
Toll-Free 1-888-313-2665

Visit us on the Internet at www.arcadiapublishing.com

This book is dedicated to Lee and Polly Banks.

CONTENTS

FOREWORD

A mother and daughter have captured bits and pieces of bygone years in the life of Manchester, small county seat of Coffee County, Tennessee, incorporated in 1905, and preserved 70-plus years of that frozen time in a collection of postcards. Memories galore recall days when the courthouse, built of bricks in the 1870s, swarmed like a beehive on Saturdays, and when farmers and their families came to town, many in the early 1900s in horse-drawn wagons. Memories linger of Hugh Doak, editor and publisher of the *Manchester Times* for almost a half-century, snapping hundreds of photographs.

Selling melons, tomatoes, corn, and fruits around the courthouse was common in bygone days. Politicians seeking votes and preachers, musicians, bankers, and whittlers gathered where travelers from Chattanooga to Nashville found Manchester to be an interesting stopover long before the interstate connected those two major cities. For many years, constables and justices of the peace played major roles in outlying districts of Coffee County.

Small rural stores such as Stepp's Store in Noah stocked dry goods, groceries, and hardware items as well as perishable groceries. Hillsboro, Prairie Plains, Fudge-Around, Rutledge Falls, Goosepond, Pocahontas, HooDoo, Beech Grove, and Gossburg are only some of the small pockets surrounding Manchester. For years, "country correspondents" from communities throughout Coffee County wrote weekly columns for the *Manchester Times*. Basil B. McMahan, who had served as a state representative before establishing his bookstore in Manchester, was author in 1983 of *Coffee County Then and Now*, perhaps the most thorough of several Coffee County histories. McMahan reminded readers that "until the third Treaty of Tellico (1805) to Duck River and Dearborn's Treaty of January 7, 1806 southward, this area was Indian Territory."

For many years, before modern voting machines were adopted, crowds would assemble on the square in Manchester until near dawn on election night, watching the changing chalkboard in the window of the *Manchester Times* in Doak's old building.

The Coffee County Fair was long heralded as the "oldest free fair," Old Stone Fort State Park (land preserved by John Chumbley) drew Gov. Frank Clement for the dedication, and Joe Frank Patch was longtime principal of Coffee County's Central High School. Bankers such as Grady York and E.W. Smartt Sr. and Jr. and hundreds of businessmen and -women, dentists, doctors, lawyers, and merchants have passed through the little town named after a city in England. Jane Banks Campbell and Lori Jill Smith are here sharing bits and pieces left over from yesterday.

—Weldon Payne

ACKNOWLEDGMENTS

We would like to thank the following individuals and institutions for making this publication possible by generously sharing postcards from their collection, by sharing their time and expertise, and by all the other countless ways of giving that made this research project so rewarding and enjoyable for us: Mark Barron, Charles E. and Nellie Brantley, Winfred Carden, Coffee County/Manchester/Tullahoma Museum, Inc. (CC/M/T Museum, Inc.), Coffee County Manchester Public Library staff, Hugh Michael Doak (whose great uncle and namesake, Hugh Doak, was the photographer/publisher of many of the postcards in this volume), Jamie Dudiak, Elizabeth Gurley (our Arcadia editor who always showed us patience and much support), Becky Haggard, David Hickerson, Louise Yates Haley, Pete Jackson (one of the county's most recognized and appreciated collectors of Coffee County memorabilia), Peggy McColloch, Teresa McCollough, Ruth Banks Morton, fellow Arcadia author Billyfrank Morrison, Carolyn and Mike Northcutt, Atha Ogles, former *Manchester Times* editor and author Weldon Payne, fellow Arcadia author Lisa Ramsay, Charles Sherrill, Tomye and Andrew Jackson Sherrill Jr., Alline Banks Sprouse, State of Tennessee Library and Archives, Marvin Stepp, Debbie Stribling, Ridley Wills II, Keith Wimberley, Judy F. Worthington, PhD (Arrowheads to Aerospace Museum), Jerry D. Yates, and Ken and Janie York.

We are also very grateful to our families, who gave us their patience, love, and support while we completed this project—to our husbands, Ronald Payton Campbell and Nathaniel Starbuck Smith; to our wonderful mother and grandmother, Polly Banks; and to other family members, including Phoebe and Amelia Smith; Kelly, Jason, and Bailey Rosalia; Jill Banks; Joan DeLisle; and Richard Banks.

With the exception of a few photographs, every image in this book is taken from an actual vintage postcard. Unless otherwise noted in the courtesy lines, all images are from the authors' collection. Again—many thanks to everyone for sharing your postcards, valuable help, much appreciated time, and wonderful memories with us.

INTRODUCTION

This book celebrates the historical heritage and beauty of Manchester and its surrounding communities through more than 200 vintage postcards depicting the area from the early 1900s through the 1970s. The postcards allow the viewer to imagine what it could have felt like to have been there decades ago by providing visual records of familiar places at an earlier time. The visual art of postcards is now acclaimed as an important way to document the past and to create a sense of place.

In 1836, Manchester was established as the county seat of Coffee County, which was named after Gen. John Coffee, a close friend and nephew by marriage of Andrew Jackson who fought alongside him at New Orleans in the War of 1812. The town, which was named after Manchester, England, lies on the south side of the Duck River and is centrally located between Chattanooga and Nashville, being about 65 miles southeast of Nashville. It is an area that has historically been home to diverse industry and productive farms.

Indeed, the Manchester area is a place that deserves to be celebrated and remembered for all of its rich history and stories of people, places, and happenings. The town is unique not only because of its geographical location in the Highland Rim at the base of the Cumberland Plateau, water sources, and beautiful rural landscape, but also because it is home to the mysterious Old Stone Fort State Archaeological Park and lies in close proximity to Arnold Engineering Space Institute, the former home of Camp Forrest.

This book is divided into eight chapters. The first chapter, "The Courthouse," starts at the center of the town with the stately, recognizable building that has proudly stood since its construction in 1871. The postcards and captions in this chapter chronicle the courthouse through the years as well as some of the important events that happened around the square, including the Century of Progress Centennial Celebration in 1936, Roy Acuff's political rally when he made a bid for governor in 1948, and the first Old Timer's Day event in 1964.

The second chapter, "The Square and Downtown," has postcards depicting the square as a busy hub of businesses and activity. During the first part of the 20th century, it became the place to congregate for county residents as they did business, shopped, and celebrated many scheduled town events while having a good time visiting with each other. The postcards in this chapter capture images of businesses that no longer exist, including Locke's 5 and 10, the Welcome Inn, Segel's, Lyric Theatre, City Café, and Henley's Department Store.

The third chapter, "Around Town," contains postcards of the town's businesses off the square, four of the early churches in the area, prominent residences, and public buildings, including the old Central High School, where many memorable events took place from 1911 until the 1970s.

The fourth chapter, "Country Life," has postcards that were created as photographers ventured out from town to the wonderful communities that surround it in order to showcase places, businesses, people, and events in some of the rural areas. Images of activities such as molasses being made, as shown in two of the postcards, helped define and create a vision of rural life in the South.

The fifth chapter, "Scenic Views and Roads," has postcards displaying some of the area's most beautiful landscapes as viewed by motorists. This chapter begins with Hugh Doak's postcard of a stretch of Highway 41 in the 1940s as it cuts through a rock cliff in the Noah community, almost 10 miles northwest of Manchester. Doak entitled the card *Gateway to the Highland Rim*. This postcard is special to the authors because the scene overlooks the home place of the authors' parents/grandparents. It was the first postcard that the authors collected more than 10 years ago, and it led to their desire to collect other vintage Manchester and Coffee County postcards. Doak photographed this scene from several viewpoints as motorists were headed in both directions. He also entitled some cards of this scene *The Road to Dixieland*. Walter M. Cline also published a view of this scenic Highway 41 landmark and entitled his card *The Big Cut*.

The sixth chapter, "The Duck River, Lakes, and Waterfalls," has postcards depicting various scenes along the Duck River, including its many waterfalls, the dam at Morton's Lake, and scenes at Lusk Mill. This waterpower was central to Manchester's early industry-based businesses. Other cards, including fishing and boating scenes at Morton's Lake and at Womack Lake and the falls at Rutledge Falls, show the many recreational opportunities that were available in the area.

The seventh chapter, "Tourists Courts, Hotels, and Motels," includes postcards showcasing many of the quaint places travelers could stay on their journeys along Highway 41. Many of these postcards show scenes from the tourist courts dotting Highway 41, including Moonlight Court, Yankee Lodge, Hoosier Court, and the Tennessee Motel. During these times, many motorists traveling the length of Highway 41 from north to south well remember Manchester as a town to stop in and perhaps spend the night before they traversed Monteagle Mountain. This fact accounts for the large number of postcards, especially of the lodging establishments, that were bought and sent during these decades. Even though it was a small town, it always had the reputation for being a place that welcomed and treated travelers well—as evidenced by all the many "wish you were here" messages sent out across the country postmarked Manchester, Tennessee. Fortunately, many of these postcards, like the ones selected for this book, still exist in archives and private collections.

The eighth and final chapter, "Miscellaneous," includes postcards of scenes of the buildings and soldiers at Camp Forrest in the 1940s. The installation of Camp Forrest and its many soldiers stationed there wrote a new chapter in the history book for Manchester. This chapter also includes postcards depicting nature scenes photographed by Walter Cline, a couple of novelty romantic postcards from the area, and a QSL radio postcard.

Many of the postcards collected for this book are of the real-photo type, which involves a photograph being directly printed onto postcard paper stock. Many of these were photographed and published by Hugh Doak, editor and publisher of the *Manchester Times* for more than 42 years (1916–1958). The Who's Who Publishing Company listed him in its *Prominent Tennesseans 1796–1938* edition and recognized him as one of Tennessee's outstanding editors and newspapermen. He served for three years as president of the Tennessee Press Association. He was often seen around town with his camera and was constantly taking photographs documenting the happenings of the Manchester area and its people. While Doak was producing and selling the Manchester postcards as a business enterprise, he probably could not foretell the lasting historical footprint created by his endeavor to record the many sights and warm hospitality of Manchester and Coffee County.

Walter M. Cline and his son Walter M. Cline Jr. were noted photographers from Chattanooga who visited the Manchester area and captured many picturesque scenes during photographic excursions to Coffee County. They also published their real-photo postcards with beautiful views taken throughout the area. Within this book is a selection of some of their work as well

as that of others who captured in art what the area looked like during the first seven decades of the 20th century.

The postcards were created and sold as a business enterprise that was successful for two primary reasons. Firstly, Manchester was a town where a flux of travelers on Highway 41 often stopped. This was the direct route that motorists journeyed from Chicago to Miami. At that time, Highway 41 came up jail hill, ran on the west side of the courthouse, made a left on Main Street, and turned right at Woodland Street and then left on Hillsboro Road. Along this route, restaurants, tourist courts, stores, gasoline stations, and a host of other businesses catered to out-of-town guests. Many of these establishments sold the postcards for people to send back home to friends and family as well as to keep for souvenirs. Secondly, Doak printed the postcards so that soldiers stationed at nearby Camp Forrest could write home and show loved ones what their "new home" was like.

Of the many postcards that were mailed from Manchester to people throughout the country, several of them had very entertaining and sometimes humorous messages penned by the sender. The ones sent by soldiers stationed at Camp Forrest were often very poignant. The backs of a few select postcards with penned messages are shown in this collection, while select passages from messages are given in the text accompanying some of the other postcards.

Along with interviews with individuals who so generously shared their time and memories, the authors have relied on previously published research for factual information to include in the caption text for each postcard. These valuable sources include Basil B. McMahan's *Coffee County Then and Now*, Dr. Judy F. West's *Manchester, Coffee County, TN: A Business and Community Pictorial Heritage*, Coffee County Heritage Book Committee's *The Heritage of Coffee County Tennessee 1836–2004*, Corinne Martinez's *Coffee County from Arrowheads to Rockets*, and archived stories from the *Manchester Times*.

Fortunately, Manchester and its surrounding communities have many saved and cherished images to showcase its historical record. The postcards within this book can only offer a glimpse of this story, but hopefully this collection will inspire its readers, as it did its authors, to research and to remember more of Manchester's intriguing and often inspiring visual heritage.

One

The Courthouse

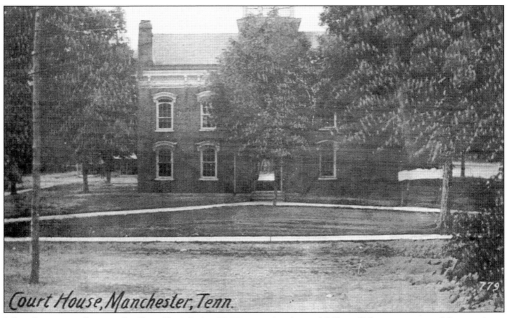

Court House, Manchester, Tenn.

The first courthouse, built of brick in 1837, was in the middle of the square and burned on December 28, 1870. The county's deputy clerk took some records home that were saved, and other deeds and books were retrieved by citizens from courthouse offices during the fire. This postcard, postmarked December 30, 1915, was mailed from Tullahoma to Laura Bell in Manchester. (Courtesy of Pete Jackson.)

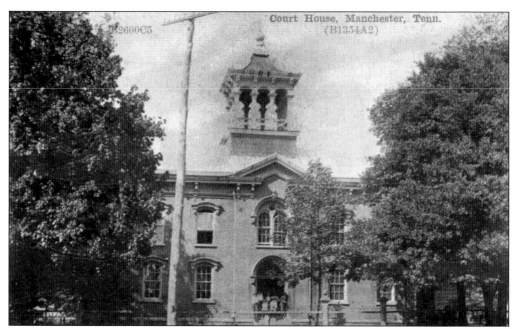

Unidentified men pose for a picture at the entrance to the new courthouse, built in 1871. Note the columns and fence encircling the building during this time as well as the light post. The fence around the courthouse was used as racks for hitching horses. According to the June 13, 1947, *Manchester Times*, in the early 1900s, Manchester had the only blacksmith shop located in a Tennessee courthouse yard.

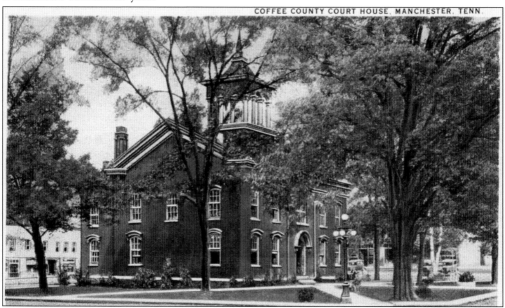

This postcard is a rendering showing the Italianate–styled architecture of the courthouse, which features an arcaded cupola. It was sent to Mrs. B.E. Norris in Bells, Tennessee, in 1930. Six years later, the Coffee County Century of Progress Centennial Celebration was held around the stately courthouse and square with exhibits and speeches. Leighton Ewell's *A History of Coffee County* was published as part of the 1936 celebration.

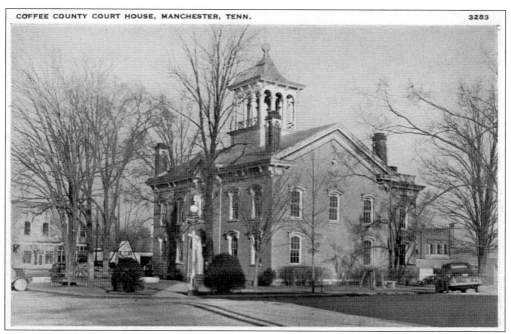

This view shows the front entrance to the courthouse, which originally had four entrances. Around 1915, vaults were installed, and two of the entrances were enclosed. Later, the courtroom area was enlarged and a hallway was added, along with two jury rooms upstairs and an enlarged office space downstairs. The building is in the National Register of Historic Places. (Courtesy of Pete Jackson.)

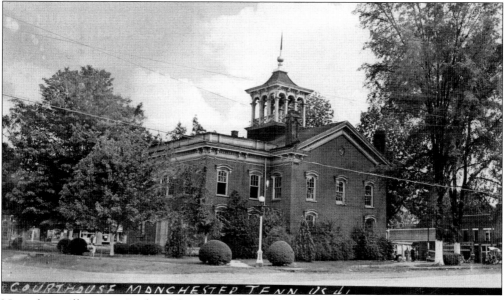

Note the artillery gun in the right corner. According to the September 23, 1938, *Manchester Times*, the German 77 gun was among the arms surrendered to the American armies at the close of World War I, and it was given to the Manchester American Legion Post in 1924 as a memorial to the American soldiers who fought. This gun later would be donated to be melted for the World War II effort.

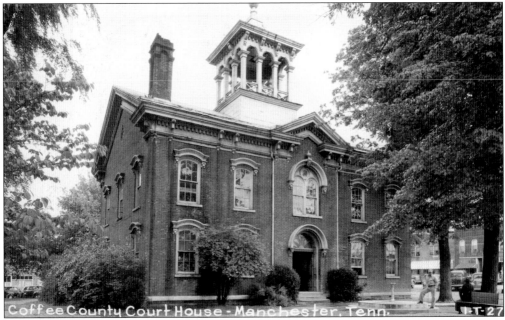

In this early postcard photographed by Walter M. Cline, two unidentified men visit in front of the courthouse. One rests on a bench beneath a tree, while the other stands next to a fountain. A renovated fountain at the same location decorates the lawn today. It was dedicated to Judge John Wiley Rollins in 1999, compliments of Sheriff Steve Graves and the Coffee County Sheriff's Department.

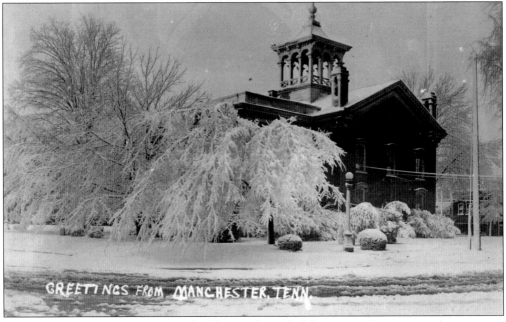

This real-photo postcard photographed by Hugh Doak following an ice storm and snowstorm shows the stately courthouse frozen in time. Note that the icy tree limbs are bent to the ground, and it appears that all activity has stopped around the square. This scene was probably taken in January 1940, when the Manchester area received more than seven inches of snow.

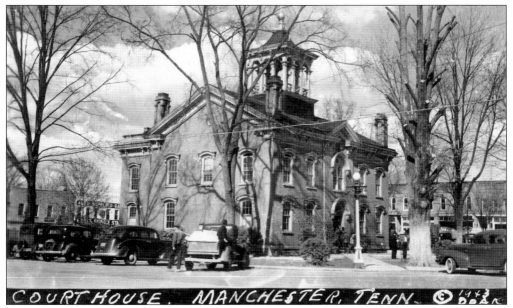

These two postcards, photographed by Doak in the 1940s, show what a busy hub the courthouse square was for citizens, especially on Saturday. The square hosted auctions, rummages, raffles, medicine shows, political speakers, checker tournaments, marble games, singing, sidewalk preachers, men whittling, and many other gatherings on the courthouse lawn. According to Ruth Banks Morton, as a young girl, she once saw a courthouse employee who had a ground-floor office raise his window and make a bid during an auction. In the card above, to the left of the courthouse can be seen Earl's Service Station and Supply. Owner Jesse Earls Sr. installed the first electric gas pumps in Manchester, selling Sunoco gas. Later, he closed this business and opened a grocery store. In the card below, a group has congregated in front of the First National Bank building.

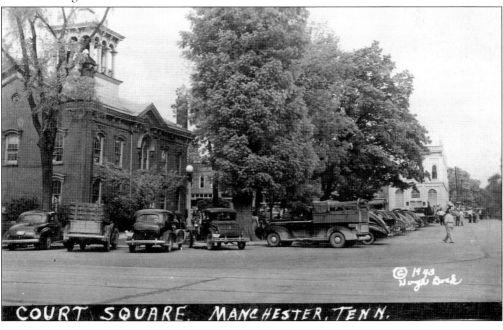

15

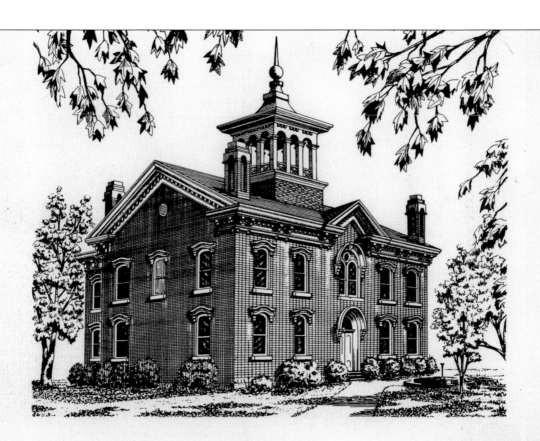

OFFEE COUNTY COURTHOUSE *Don Northcutt* BUILT 1871 MANCHESTER, TENNESSE

This postcard is Don Northcutt's pen-and-ink rendering of the courthouse. His exquisitely rendered historical drawings of Coffee County visually preserve the area's heritage. Manchester, with the courthouse as backdrop, has welcomed noted politicians and celebrities throughout the years. On October 1, 1948, Roy Acuff, who was the Republican nominee for governor of Tennessee, spoke to the largest political gathering of the year on the courthouse square. With his band, the Smokey Mountain Boys, he sang, played his fiddle, and made a speech in which he said that, if elected, he would continue to perform an hour's program for the weekly Grand Ole Opry. However, he lost the election to the Democratic incumbent Gordon Browning. Acuff, who later would be known as the king of country music, was elected to the Country Music Hall of Fame in 1962 as its first living member. Starting in 2002, Manchester became host to the Bonnaroo Music and Arts Festival, which has become an annual four-day music festival held on a 700-acre farm near town with leading artists in the music industry performing for visitors from around the world. (Courtesy of Carolyn and Mike Northcutt.)

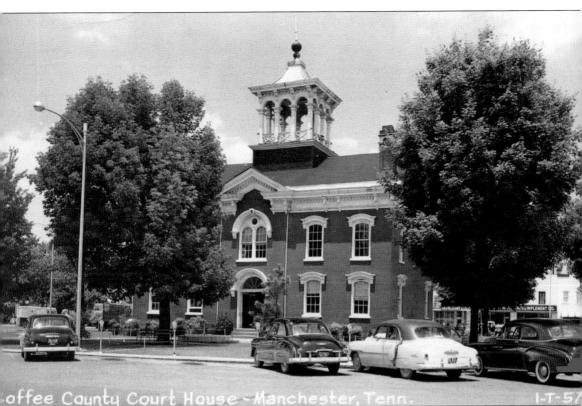

offee County Court House - Manchester, Tenn. 1-T-57

Parking meters line the sidewalks around the courthouse in the 1950s. Today, the lawn is graced with memorials to honor the county's fallen soldiers in the Civil War, World Wars I and II, the Korean War, and the Vietnam War. The postcard shows the courthouse before it underwent renovation in 1973. Upstairs in the courtroom, portraits hang of several men who were important to the county's legal history: Joseph Leighton Ewell, who practiced law for 45 years in Coffee County; A.J. Marchbanks, circuit judge (1844–1861); William P. Hickerson Sr., circuit judge (1865–1867 and 1869–1877); Joseph C. Higgins, circuit judge, (1902–1910); Ewin L. Davis, circuit judge (1910–1918); Robert W. Smartt, circuit judge (1918–1950); Horace James Garrett, chancellor (1954–1961); and John Riley Rollins, circuit judge, (1990–2009). Today, cases for circuit court and chancery court are still held in the courtroom located upstairs.

This postcard shows the historic courthouse where the first Old Timer's Day was held around the square on October 24, 1964. Featured were a parade, square dance, and contests. Some of the contest winners were George T. and Elize West, named Mr. and Mrs. Old Timer for the longest marriage of 68 years; the largest family in attendance to the J.R. Wiser family of Blanton's Chapel; the most appropriately dressed to Mary Lee Crocker and Doug Bryan; first place for the best coon dog to Paul Beavis; first place for the best beagle to Jackie Meadows; first place in the log-sawing contest to Hall Jacobs of Manchester and Rayford Arnold of Noah; and first place in the hog-calling contest to Woodard Stacey of Busy Corner. The courthouse today houses a Tennessee Highway Patrol Criminal Investigation Division office, a University of Tennessee Agricultural Extension, and the Coffee County Historical Society. (Courtesy of CC/M/T Museum, Inc.)

Two

THE SQUARE
AND DOWNTOWN

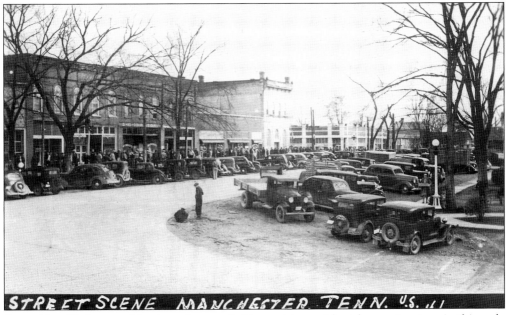

An unidentified man with a large bag, probably awaiting a ride, takes center stage in this early postcard of the square's northeast corner. In the middle of the row of stores is McCroskey's 5 and 10 store, owned by Laura McCroskey. She opened the variety store in 1938, and in 1949, her nephew Omer Rogers bought the store, which later became Rogers 5 and 10. (Courtesy of Peggy McCulloch.)

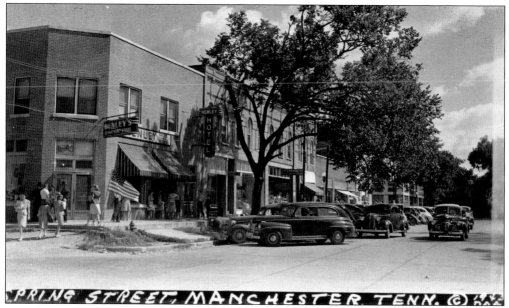

This real-photo postcard by Doak in the early 1940s looks south down Spring Street on the northeast corner of the square. Henley's Department Store is on the corner, with Henley's Hotel upstairs. Next to McCroskey's 5 and 10 is Sam Sir's. A few doors down is Locke's 5 and 10, where Gertrude Templeton started working as a manager in 1940. Note the American flag and the tree-lined street.

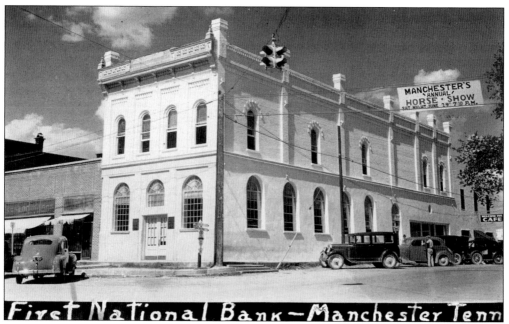

Shown is the First National Bank in 1940 as the town awaits its annual horse show, set for June 29. In 1915, William H. Ashley served as president and was succeeded by William P. Hickerson Jr. In 1976, America's bicentennial year, Waterhouse Euclid Smartt Jr. was president and chairman of the board. In 1952, Dr. Edwin J. Threet, a dentist, began his professional practice on the second floor of the bank building.

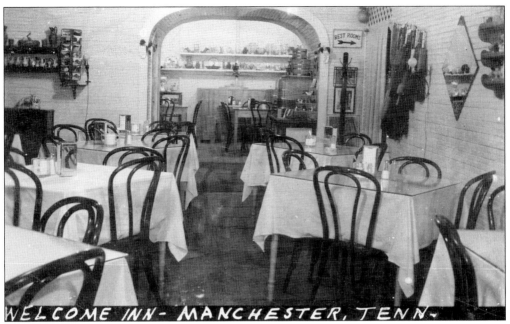

Behind the bank a few doors down on East Main Street was the Welcome Inn. Note the postcard rack to the left of the arched doorway that offered souvenirs for travelers to send back home. Advertising photo cards "6 for 25¢," the rack contains some cards that are identical to ones published in this collection.

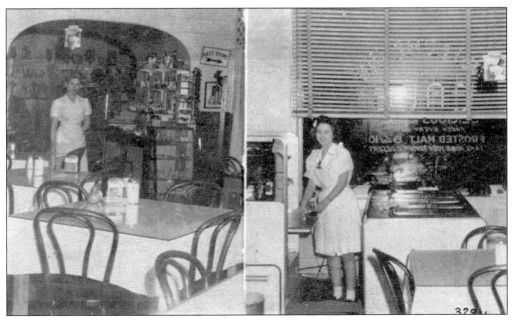

Highway 41 was East Main Street in front of the Welcome Inn. Homemade ice cream was a favorite of tourists who also enjoyed shopping in the gift shop. E.W. Lovell operated the café until 1936, when Ray S. Reiling became the new owner. Reiling also offered tourist rooms on the second floor. (Courtesy of Pete Jackson.)

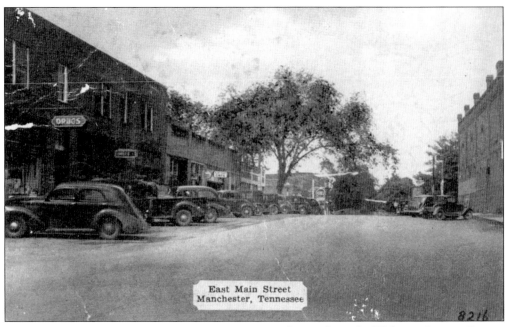

East Main Street
Manchester, Tennessee

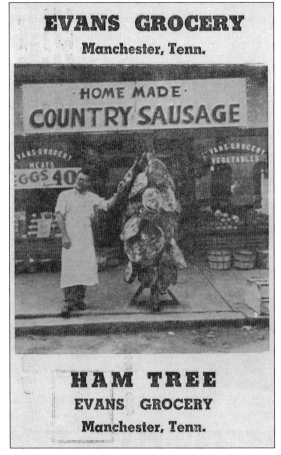

Across from the Welcome Inn on East Main Street was Baker Drugs, opened in 1928 by Thurman Dee and Lee Baker and later partnered and then owned by Harold Denton "H.D." Marcrom, along with Robert St. John. Dr. Horace Farrar's medical clinic and Dr. Wyrtt Winton's dental office were on the second floor. Dr. Farrar delivered many of the county's baby boomers in his clinic. (Courtesy of Ruth Banks Morton.)

Henry Clay Evans displayed his ham tree outside Evans Grocery at 106 East Main Street to attract the many motorists who drove Highway 41 past his store. He and his wife, Jane, operated the store from 1945 to 1973. He relied on area farmers to provide him quality hickory-smoked, sugar-cured country hams to sell. (Courtesy of Pete Jackson.)

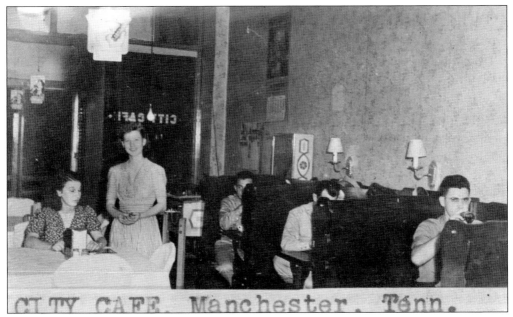

Because many travelers made their way through downtown Manchester via Highway 41, several cafés offered delicious food. One of these on East Main Street was the City Café, also known as the Manchester Café and once operated by E.W. Lovell. Above, unidentified diners and waitresses enjoy food at the busy café. Note the pinball machine. According to Jerry D. Yates, pinball machines in the business were owned by Pvt. Perry S. Shockley, who owned several machines around town. Among the other cafés available and their operators were the Chatterbox, Walter Thomas "T" Richardson and later Leon Trail; the Lewis Café, Herbert and Clatie Lewis; and Fats and Spang's Place, Orien McBride and Ralph Spangler. Below, unidentified soldiers enjoy a home-cooked meal. Note the tabletop jukeboxes available for each customer. (Both, courtesy of Atha Ogles.)

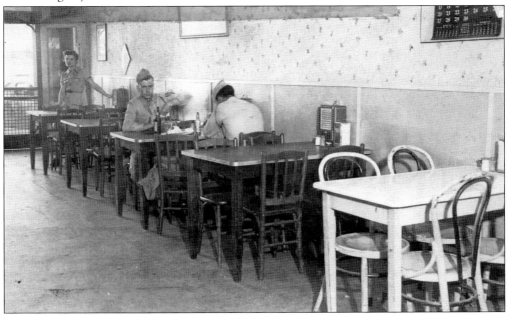

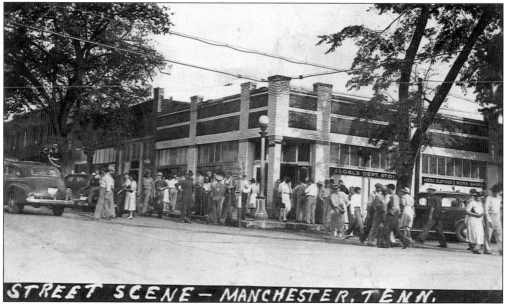

STREET SCENE — MANCHESTER, TENN.

This postcard, photographed by Doak in the 1940s, spotlights Segel's Department Store on the square at the corner of South Spring and East Main Streets. Shoppers are awaiting one of the store's popular marketing events that featured free merchandise giveaways. Some promotions involved an employee standing on the roof and throwing prizes to the crowd below. This corner previously was the site of one of the town's earliest motels, the Windsor.

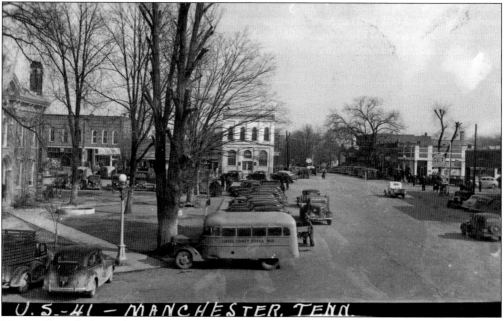

U.S.-41 — MANCHESTER, TENN.

Two unidentified men lean against a truck bed just past the school bus as they watch the traffic pass on Highway 41. Motorists could fill up with gasoline at the Gulf station on the corner of Spring and Main Streets or the Esso station farther down the street. So many gasoline stations were available around the Manchester area in the 1940s that the stretch was regarded as "Gasoline Alley."

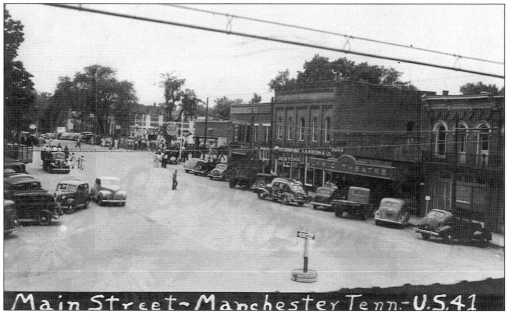

Main Street~Manchester Tenn.~U.S.41

As Highway 41 travelers arrived downtown and turned left on Main Street, they were guided by the sign pointing toward Chattanooga. Note the car with white writing in front of the Lyric Theatre that depicts admission price and featured movies. This was a popular way to advertise. Down the street, a crowd forms at Segel's Department Store, which is celebrating its 30th anniversary after opening in 1911.

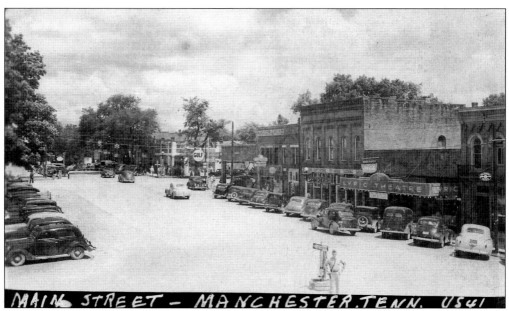

MAIN STREET — MANCHESTER.TENN. US41

This real-photo postcard by Doak shows a soldier directing traffic on Main Street. In 1936, the Lyric Theatre took center stage on this side of the square and was the town's first to offer a "talking picture." Prior to that, Claude Winton opened the first moving picture theater in the Odd Fellows building. (Courtesy of Peggy McColloch.)

LYRIC THEATRE

Manchester, Tennessee

SATURDAY, MARCH 12
Wm. BOYD in
'Hopalong Cassidy Returns'
Added A POPEYE COLOR CARTOON COMEDY

SUNDAY and MONDAY, MARCH 13-14
JEANETTE MAC DONALD'S Latest Musical
"The Firefly"
Added 2-Reel Fox Comedy "Freshies" Fox News.
Matinee, Sunday 12:45 and 3:30. Night, 8:45

TUESDAY, MARCH 15
Register for Opportunity Nite
ELEANOR POWELL in
"Born to Dance"
Also Selected Short Subjects
This Picture Will Be Shown ONE DAY ONLY.

WEDNESDAY, MARCH 16
OPPORTUNITY NITE
JACK OAKIE and JOHN BOLES in
"Fight For Your Lady"
Comedies "Hula Heaven" and "Rhythm Wrangles"
Matinee, 1:45 p.m.

THURSDAY and FRIDAY, MARCH 17-18
You may have seen the REST, now see the BEST
of the WESTS! MAE WEST in
"Every Day's A Holiday"
Added: Musical Comedy "Sometime Soon"
R. K. O. Comedy "Sweet Shoe"

SATURDAY, MARCH 19
GARY COOPER and JEAN ARTHUR in
CECIL B. DeMILLE'S
"The Plainsman"
Also a Big POPEYE COMEDY "I Like Babies
and Infinks". Chapter 3 "Wild West Days"

The Brashear family from Pelham was mailed this postcard in 1938 advertising the movies for the week of March 12 to March 19 at the Lyric Theatre. Note that the features on the two Saturdays were Westerns, a popular genre at this time. William Boyd starred in *Hopalong Cassidy Returns*, and Gary Cooper starred in *The Plainsman*. Attendees also were shown Popeye cartoons. (Courtesy of the Tennessee State Library and Archives.)

LYRIC THEATRE

MANCHESTER. TENN.

SATURDAY, MARCH 19
GARY COOPER and JEAN ARTHUR in
Cecil B. DeMille's
"The Plainsman"
Added: POPEYE COMEDY Chap. 3 Wild West Days

Your Lyric Theatre opens the Spring Season
with a Gala Week of Hits!

SUNDAY and MONDAY, MARCH 20-21
BOBBY BREEN in
"Hawaii Calls"
Added: POPEYE COMEDY and Fox News
Mat. Sunday 12:45 and 3:30. Night, 8:45

TUESDAY, MARCH 22—1 DAY ONLY
FREDDIE BARTHOLOMEW in
"The Devil Is A Sissy"
Added: A TERRY-TOONS CARTOON "Play Ball"

WEDNESDAY, MARCH 23—Opportunity-Nite
WILL ROGERS and JANET GAYNOR in
"State Fair"
Added: A TERRY-TOONS CARTOON

THURSDAY and FRIDAY, MARCH 24-25
CAROLE LOMBARD, FRED Mac MURRAY,
and JOHN BARRYMORE in
"True Confession"
Added: A MICKEY MOUSE CARTOON

SATURDAY, MARCH 26
A DOUBLE FEATURE PROGRAM!
No. 1—SMITH BALLEW and HEATHER ANGEL
"Western Gold"
No. 2—JOE E. BROWN in
"Fit For A King"

This postcard advertisement from the Lyric Theatre shows that the Saturday, March 26, moviegoers were treated to a double feature program, *Western Gold* and *Fit for a King*. The Wednesday night feature, *State Fair* starring Will Rogers and Janet Gaynor, was released earlier in 1933 and was nominated for an Academy Award for Best Picture. (Courtesy of the Tennessee State Library and Archives.)

One of the most popular movies advertised on this postcard received by the Brashears was the Saturday, April 2, 1938, showing of *Public Cowboy No. 1* starring Gene Autry. The Lyric Theatre was built in 1936 by Dr. Almon Alonzo Womack and destroyed by fire in 1937, but as evidenced by this postcard advertisement, it was remodeled and soon reopened for business. (Courtesy of the Tennessee State Library and Archives.)

Jack Thompson, a soldier in Company A, 129th Infantry stationed at Camp Forrest, selected this card of a scene at the square to send back home to Springfield, Illinois. The message, postmarked May 13, 1942, reads "I just got here. It is about 12 miles to camp." Note that Zane Grey's *Western Union*, starring Robert Young and Randolph Scott, was playing at the Lyric Theatre.

LYRIC THEATRE
MANCHESTER. TENN.

SATURDAY MARCH 26
DOUBLE FEATURE PROGRAM!
No. 1—SMITH BALLEW in
"Western Gold"
No. 2—JOE E. BROWN in
"Fit For A King"
Added: Harmon-Ising Cartoon "Pipe Dream"
Chapter No. 4 "WILD WEST DAYS"

SUNDAY and MONDAY, MARCH 27-28
NELSON EDDY and ELEANOR POWELL in
"Rosalie"
Special Added: Featurette of the Dionne Darlings in
"QUINTUPLAND" Fox Movietone News
Matinee—Sunday 12:45, 3:30 Night—8:45

TUESDAY, MARCH 29—ONE DAY ONLY
JANE WITHERS in
"45 Fathers"
Added: 2 Reel Comedy "Holding the Bag"

WEDNESDAY, MARCH 30—Opportunity Nite
JOHN WAYNE and DIANA GIBSON in
"Adventure's End"
Oswald Cartoon Comedy "Mechanical Handyman"

THURSDAY and FRIDAY, MARCH 31, APRIL 1
KATHERINE HEPBURN and CARY GRANT in
"Bringing Up Baby"
With CHARLES RUGGLES

SATURDAY, APRIL 2
GENE AUTRY in
"Public Cowboy No. 1"

NEXT WEEK—"You're A Sweetheart,"
"Badman of Brimstone"

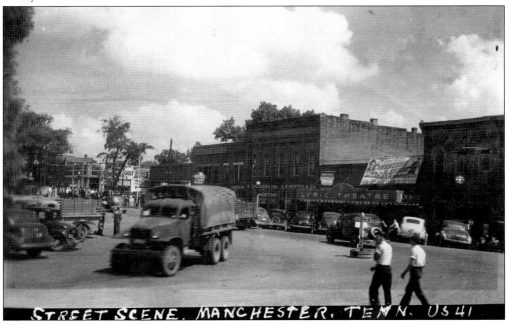

STREET SCENE. MANCHESTER. TENN. US41

27

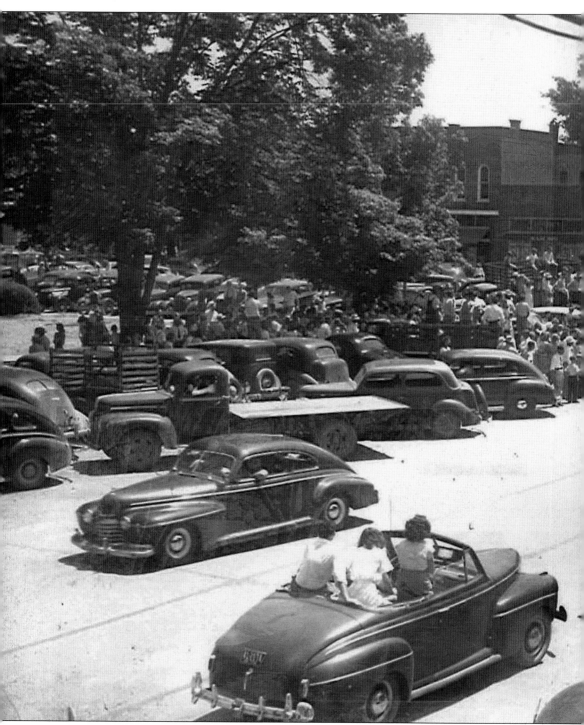

Marching band members and majorettes can be seen encircled by the crowd in this postcard, which shows a view of the town square in the late 1930s or early 1940s. The banner stretching from the First National Bank (the white building in the middle) across the street partially reads: "CELEBRATION HERE, BAR-B-Q, SQUARE and DANCE." This postcard was photographed

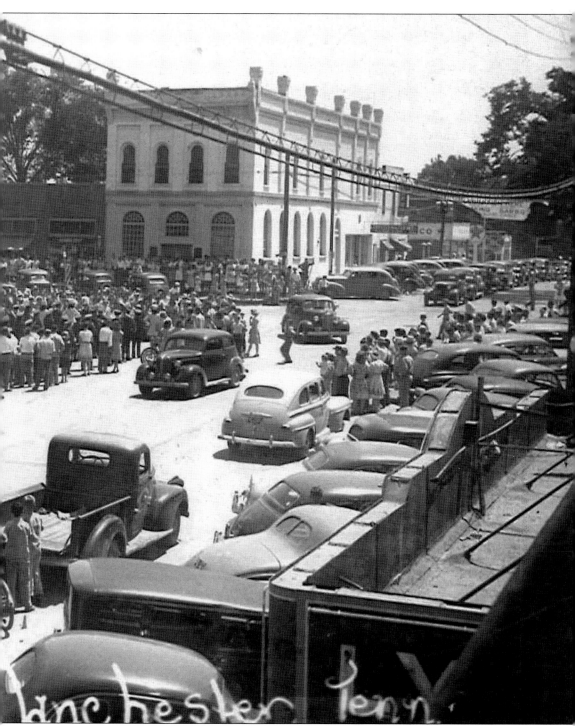

from the top of the Peoples Bank and Trust building, located at the corner of South Irwin and West Main Streets. An iron stairway at the corner led upstairs to the Southern Bell Telephone and Telegraph Company. Later, the old telephone office was remodeled as offices for attorneys David W. Shields Jr., Robert L. Keele, Harry Barr Gilley, and Robert C. LeQuire.

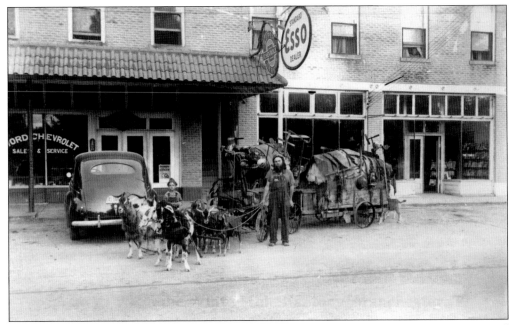

Posed in front of Word Chevrolet at the southwest corner of the square are Chess McCartney and his son with a team of goats. A resident of Jeffersonville, Georgia, he started roaming the country with his caravan of goats in the 1930s and visited Manchester every three or four years. Note the person peeking out of the window of the next building housing the *Manchester Times*.

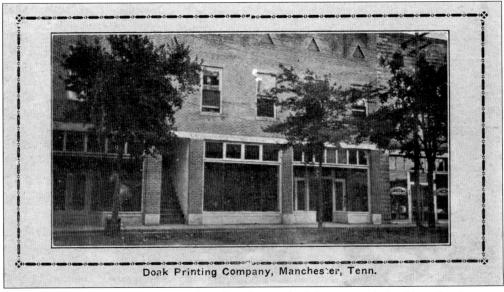

Doak Printing Company, Manchester, Tenn.

Hugh Doak, who photographed and marketed several of the postcards in this collection, was editor and publisher of the *Manchester Times* and owned Doak Printing Company located on North Irwin Street. An advertisement in the December 2, 1939, *Manchester Times* encouraged readers to send the cards "to persons who once lived here, to persons who want to move here and to persons whom you think ought to live here."

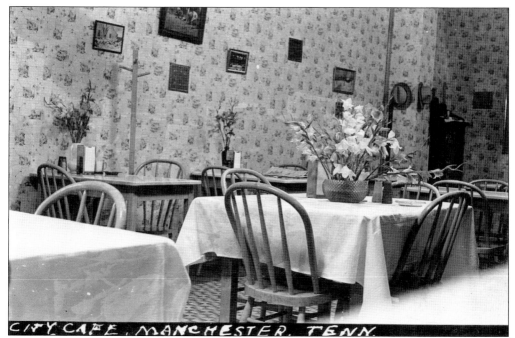

Shown in this real-photo Doak postcard is the City Café, which became a favorite stop for motorists as they entered the square via Highway 41 as well as for local diners. It was located next to the Doak Printing office and operated by Ada "Ma" Lovett, who was also known for cooking a rabbit dinner for a select group of Manchester citizens the day after Thanksgiving in 1934. This became an annual event.

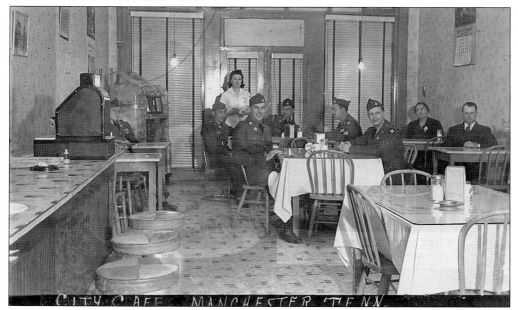

Ada "Ma" Lovett is shown in the back right corner in this postcard with soldiers from nearby Camp Forrest. Soldiers were inducted and received basic training at Camp Forrest. In June 1941, the Tennessee Maneuvers, under the direction of Gen. George S. Patton, involved 850,000 troops who received combat training for the European theater. (Courtesy of Atha Ogles.)

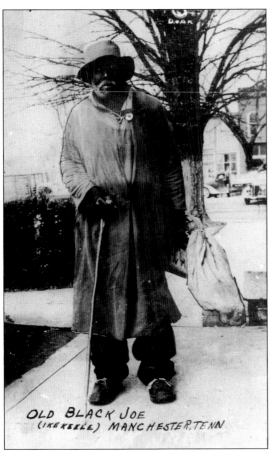

OLD BLACK JOE
(IKE KEELE) MANCHESTER, TENN

Shown in this 1930s postcard is Ike Keele, a familiar figure around the square and town. According to Ruth Banks Morton, "Daddy always had someone to help him at hog killing because it was such a big job. Uncle Ike was a good man and really enjoyed helping Daddy, or anyone, for that matter. Uncle Ike always wanted the intestines to make chitterlings, or 'chitlins,' as everyone called them."

This is an early view of the post office located at the corner of North Spring and East Fort Streets and constructed under the WPA program in 1939. From 1921 to 1931, the post office was at the corner of McLean and Spring Streets, and it was moved across the street in May 1931. (Courtesy of Billyfrank Morrison.)

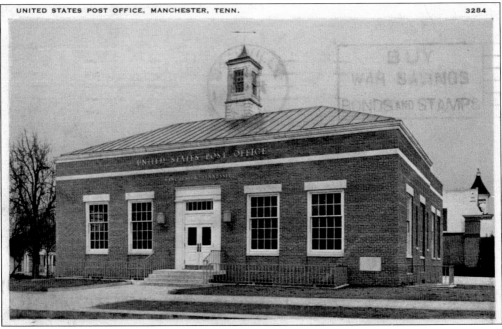

UNITED STATES POST OFFICE, MANCHESTER, TENN. 3284

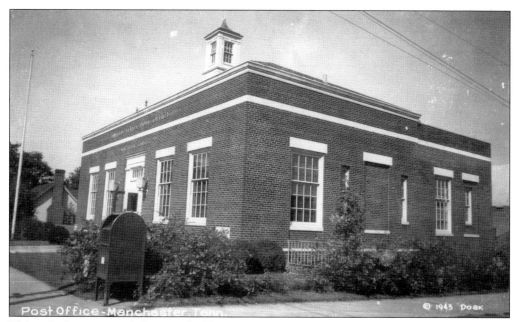

This real-photo postcard photographed by Doak highlights the Colonial Revival architecture of the post office with its hipped roof and cupola. The early postmasters were Alfred V. Boyce, Lonnie A. Jernigan, Charles V. O'Neal, C.D. McGuire, Hugh Doak, Coy St. John, George Bowlin Morton, and Jesse Larry Campbell. Today, the post office is located at 1601 Hillsboro Boulevard.

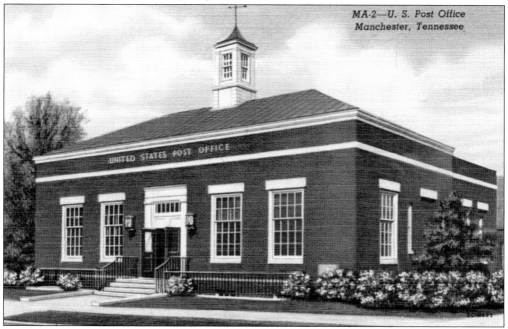

This postcard shows the beautifully landscaped post office. A WPA-commissioned mural by artist Minna Citron titled *Horse Swapping Day* graced the interior. She chose a rural theme centered at the town square with three Tennessee walking horses, one modeled after Gene Autry's horse, Champ Jr. The oil-on-canvas painting, measuring 11 feet 11 inches by 5 feet, now hangs behind the counter of the new post office.

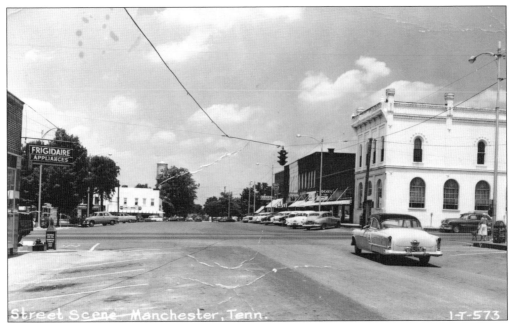

Street Scene—Manchester, Tenn. 1-T-573

Street scenes are shown around the square in the 1950s. Above is a view of Spring Street. To the left of the First National Bank building, constructed in 1895, are Locke's 5 and 10, Rogers 5 and 10, and Redd's Department Store. Everett Redd and his wife, Virginia, opened Redd's in 1944, and in 1970, they sold it to Mary Elizabeth H. Neiderhauser, who opened a dress and fabric store. Today, the law office of J. Stanley Rogers, Christina Henley Duncan, and Edward H. North occupies the bank building. Below, on the square's southwest corner is the Peoples Bank and Trust building to the right of the Lyric. It has been a banking institution since 1906. Early bank presidents were John P. Adams (1906–1924), Alfred Moore (1925–1944), Robert Hough Leming (1945–1953), Dave King (1953–1986), and Wayne Bramblett (1986–1988).

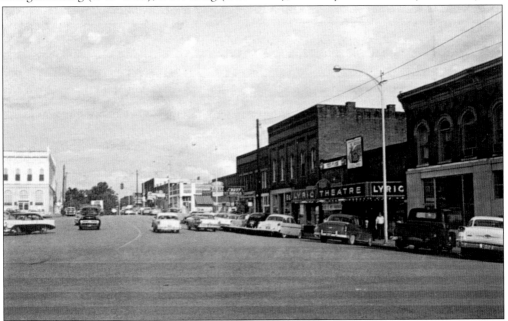

Three

AROUND TOWN

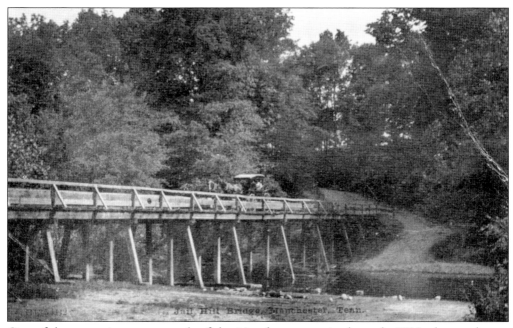

One of the most vintage postcards of the Manchester area in the early 1900s shows a buggy leaving Manchester across the old wooden Jail House Bridge. The old jail was on the hill behind the trees. The dirt road, called the Nashville Road, went down to the Little Duck River, where horses could be watered and barrels filled with water. (Courtesy of Ridley Wills II.)

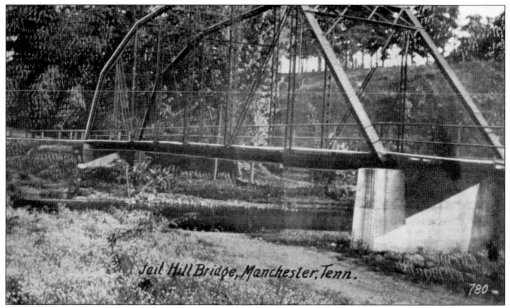

Jail Hill Bridge, Manchester, Tenn.

780

Note that the wooden bridge has been changed to an iron structure in the 1930s. Near the site of this bridge, on June 20, 1941, Gen. George S. Patton personally led his 2nd Armored Division across several fords of the Duck River and quickly surrounded and defeated his maneuver opponents. He proved that modern armor could be employed in battle with decisive effect. (Courtesy of Ridley Wills II.)

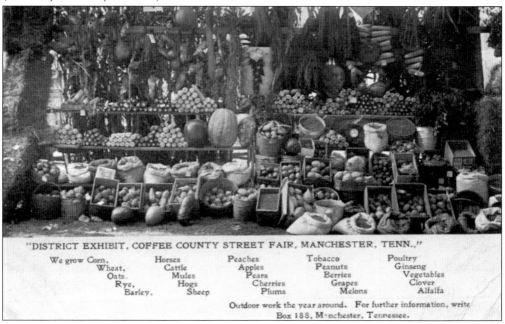

"DISTRICT EXHIBIT, COFFEE COUNTY STREET FAIR, MANCHESTER, TENN.,"

We grow Corn,	Horses	Peaches	Tobacco	Poultry
Wheat,	Cattle	Apples	Peanuts	Ginseng
Oats,	Mules	Pears	Berries	Vegetables
Rye,	Hogs	Cherries	Grapes	Clover
Barley.	Sheep	Plums	Melons	Alfalfa

Outdoor work the year around. For further information, write
Box 188, Manchester, Tennessee.

Postmarked from Manchester on November 24, 1913, this postcard was sent to David S. Martin in Lancaster, Pennsylvania, to show the plentiful agricultural products produced, displayed, and sold outdoors at the Coffee County Street Fair, which was held at various locations around town. The first fair was held around the courthouse square. In 1914, the 16th annual street fair was held on the public school campus.

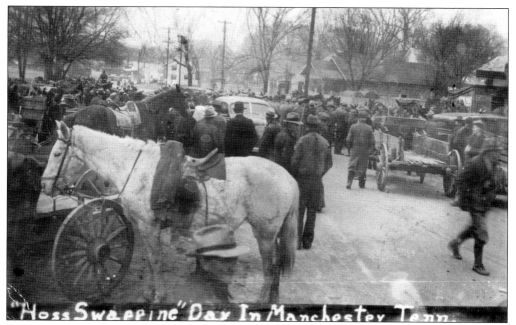

This vintage postcard spotlights one of the most anticipated events of the early 1900s held in Manchester by area rural citizens—horse-swapping day. The event was held in more than one location in town. Zeke Keele is seen in the center of the foreground. During this time, horses were an important commodity, not only for trade, but also for personal use.

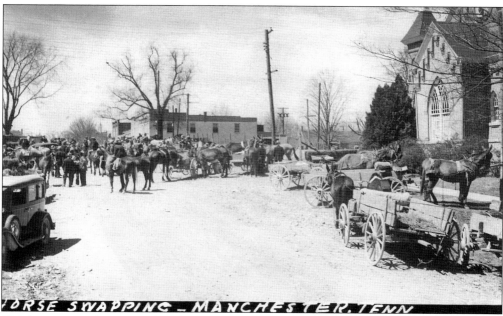

This horse-swapping event takes place on East Fort Street. The East Fort Street Church of Christ building is on the right. The new Manchester Post Office was built to the left of the church. Note that both wagons and automobiles were used for transportation to town. (Courtesy of Ridley Wills II.)

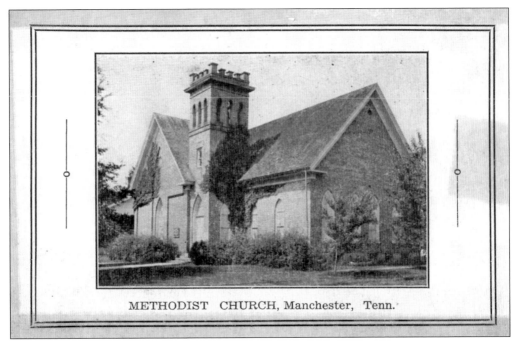

METHODIST CHURCH, Manchester, Tenn.

The Methodist church is located at its original site at 105 North Church Street. It was first built of logs in 1815 on Lot 51. In 1883, a brick structure was erected, and in 1916, the bell tower was added, as well as other additions through the years. (Courtesy of Ruth Banks Morton.)

Shown is the First Baptist Church building, dedicated on May 29, 1887, on Lot 56, later known as the corner of East Main and Woodland Streets. On April 4, 1954, first services were held in a new building at 1006 Hillsboro Boulevard. Unfortunately, a fire destroyed this building on September 29, 1981, and first services were held in the present structure on March 25, 1984. (Courtesy of First Baptist Church.)

Dedication services were held November 2, 1890, at the Cumberland Presbyterian Church, shown at right at the corner of Church and West High Streets. Anderson Powers gave the church a bell that had once been used on a Cumberland River riverboat. The bell has been used at the present location of the church at the corner of McArthur and Coffee Streets since May 28, 1961. (Courtesy of the Dean May family.)

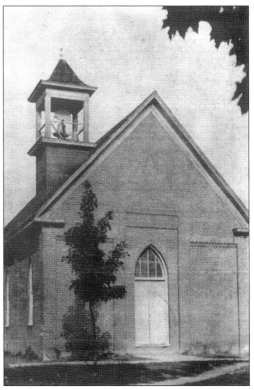

The East Fort Church of Christ was completed in January 1894. The church bell rang on Armistice Day and on August 15, 1945, when Japan surrendered ending World War II. When the congregation outgrew the building, it moved to a new location at 201 East Main Street in December 1961. The East Fort Street building was sold to the county in 1985. (Courtesy of East Main Church of Christ.)

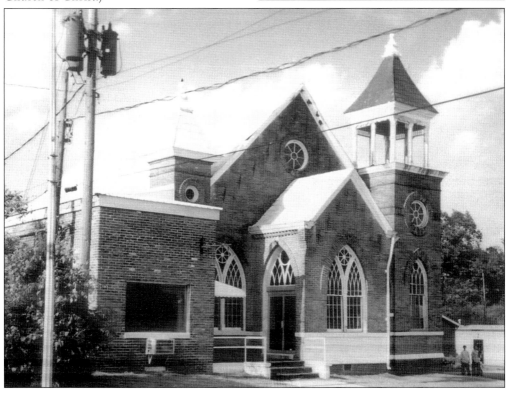

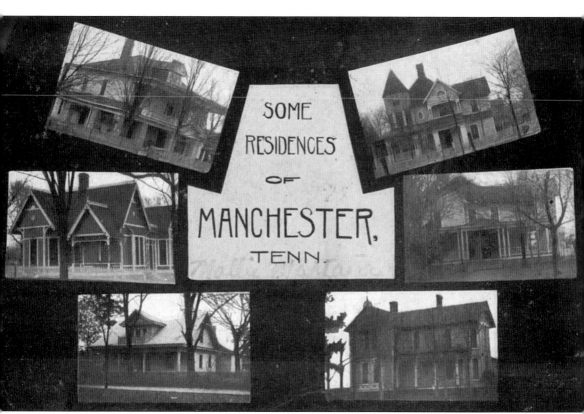

This postcard shows some of the finest homes in Manchester and was mailed from Summitville on March 25, 1912, to Mary Gladwell in Lima, Ohio. Shown from left to right and as known around town are (top) Ashley home on West Fort Street and Chumbley home on Main Street; (middle) Jackson home on Main Street and Patch home on Ramsey Street; (bottom) Manchester Funeral Home on West Main Street and the Keele home on Ramsey Street. An intriguing fact about the Manchester Funeral Home is that it was once owned by Fred Deadman and George Stroud. This oddity with names resulted in the business becoming an entry in *Ripley's Believe It or Not*. Also, the names in relation to a funeral home business were mentioned on the popular television shows *The Tonight Show Starring Johnny Carson* and *Laugh In*. (Courtesy of Ridley Wills II.)

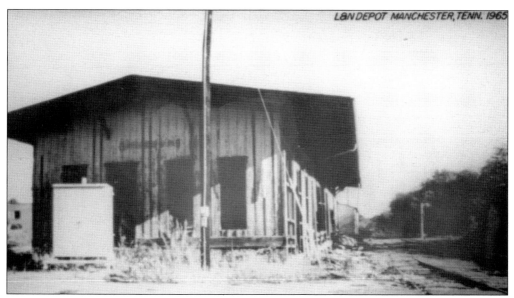

Shown above is the Manchester train depot. Peak passenger years were 1910 to 1915. Later, one passenger train car and then just one freight car ran. From 1970 to August 1983, the train ran three times a week. During Mayor Roy L. Worthington's administrations, the short line was purchased by governments of three counties and the towns therein. Since then, the train has run daily except Saturday and Sunday. Today, the short line is Caney Fork & Western Railroad and is owned by Coffee, Warren, and White Counties and municipalities. The postcard below depicts Don Northcutt's drawing of the Manchester depot. (Above, courtesy of State of Tennessee Library and Archives; below, courtesy of Carolyn and Mike Northcutt.)

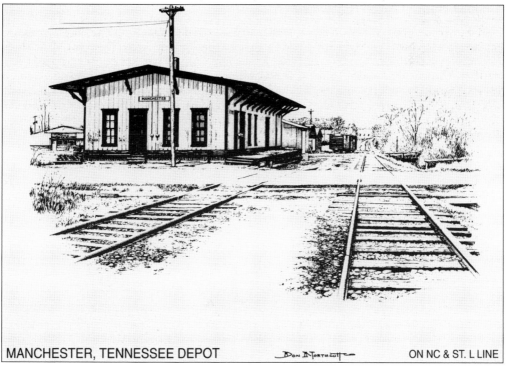

MANCHESTER, TENNESSEE DEPOT Don Northcutt ON NC & ST. L LINE

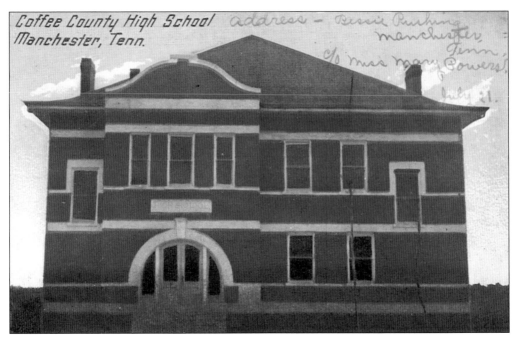

Students at the first high school in the county met for classes in the courthouse in 1910. The cornerstone for the first county high school building was laid on August 14, 1909. The first high school, shown in the postcard above, was constructed in 1911 on the location that is now 300 Hillsboro Boulevard. (Courtesy of Pete Jackson.)

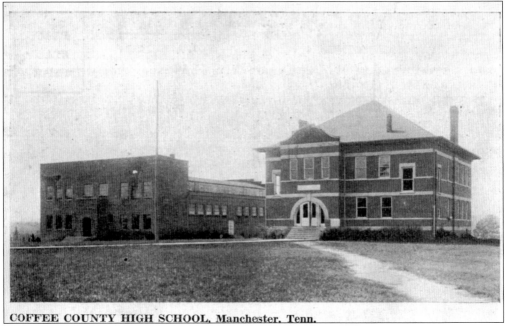

This postcard, postmarked in 1933 and sent to Mrs. Amos Davis in Lewisburg, Tennessee, shows the additions that were made to the original structure. In 1926, a gymnasium was erected. Classes were held in this gym in late 1937 and early 1938 while the new high school building was being constructed at the same site.

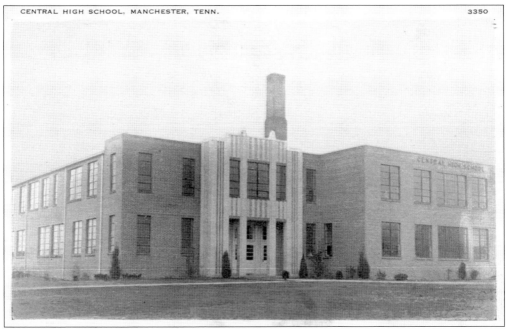

Shown in the postcard above is the new school building completed in 1938. Below is the Coffee County Central High School 1938 football team. From left to right are (first row) coach Claude Carroll, Red Miller, L.B. Myers, Hix Ramsey, John N. Davis, James Corn, Kenneth Warren, Pat Ashburn, James Winton, Carl Lasater, Tom Murphy, Fred Winton, and coach Gerald Cortner; (second row) Vaughan Christian, Louis Roberts, Boyd Jackson, T.H. Moore, Frankie Smartt, Jimmie McCroskey, Charles E. O'Neal, Charles Byford, Clarence Miller, and Phillip Willis; (third row) Charlton Carroll, Lanier Lowery, Eugene Crownover, Floyd Fetzer, Parker McBride, Armond Holmes, William Meredith, Red Uselton, Roy Bickel, Cloyd Sain, and Carl Henry; (fourth row) D.L. Casey, M.G. Wooten, Carter Cunningham (assistant manager), and John F. Brantley. (Above, courtesy of Pete Jackson; below, courtesy of Ken and Janie York.)

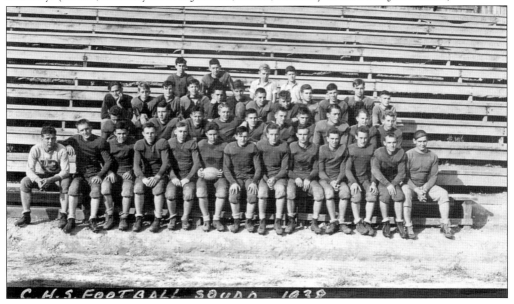

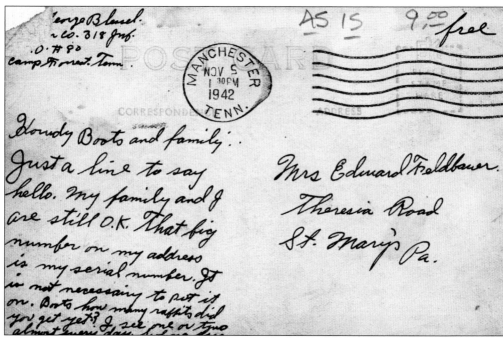

This postcard photographed by Doak in the early 1940s was sent by a Camp Forrest soldier to Mrs. Edward Feldbauer in St. Mary's, Pennsylvania, and postmarked November 5, 1942. Sometimes, cards sent back home from soldiers were very poignant, but this one's message was lighter. Note on the card above that in the message, he asks his friend Boots, "how many rabbits did you get yet?" and comments, "I see one or two almost every day." He also refers to his serial number that he receives as a soldier. Below, the front of the postcard shows the high school as it looked when soldiers passed by it on maneuvers or on the way to town.

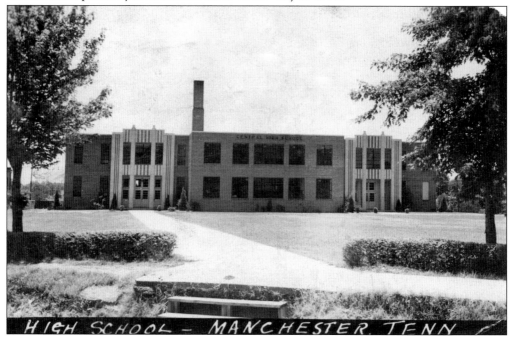

HIGH SCHOOL - MANCHESTER. TENN

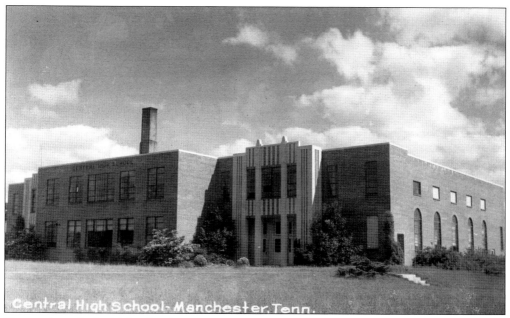

Central High School-Manchester.Tenn.

Shown above is the high school in 1941, where Gen. George S. Patton set up headquarters in the school gym to command maneuvers of the US Second Army in the Manchester area. At right, Alline Banks Sprouse began her basketball career in the early 1930s at Noah Junior High School and then attended Buchanan High School in Rutherford County. She won Amateur Athletic Union (AAU) All-American honors for 11 consecutive seasons (1940–1950). She played on four different teams during her career: Nashville Business College (1939–1942, 1949–1950), Vultee Aircraft (1943–1945), Nashville Goldblumes (1946), and Atlanta Sports Arena Blues (1947–1948). She played on five AAU national championship teams (1944, 1945, 1946, 1947, and 1950). She was recognized by *Sports Illustrated* as one of the 50 greatest sports figures from 1900 to 2000 and named to the Women's Basketball Hall of Fame in 2000. (Right, courtesy of Alline Banks Sprouse.)

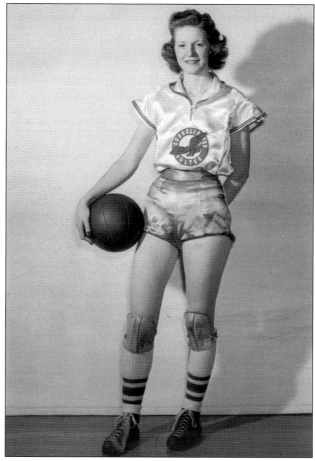

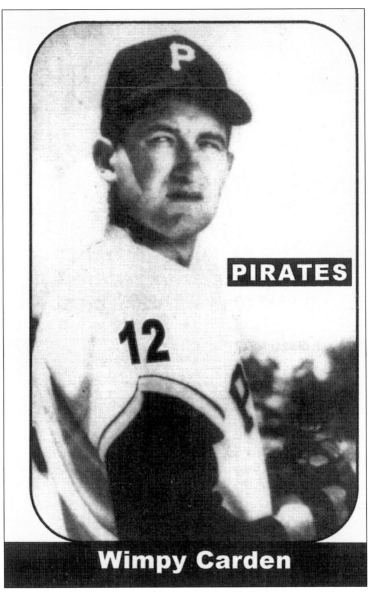

Wimpy Carden

Above, a 1948 graduate of Coffee County High School, Winfred "Wimpy" Carden was awarded the best boy athlete medal and played with the Manchester Ball Club. He joined the Pittsburg Pirates as pitcher from 1951 to 1957. Then he retired from active play and partnered with J.D. Hickerson and James Cunningham in 1961 to open Garner's Furniture and Appliances on the north side of the square and then the west side when he later gained ownership. Garner's is now located on East McLean Street. In other family-related sports activities, his brother L.D. Carden was football coach for 20 years and girls' basketball coach for 30 years, longer than any other coach in the history of the high school. He led the Lady Raiders to winning 22 of his first 23 seasons as coach. In the 1963–1964 season, the team was fourth in state, led by all-state forward Linda Umbarger. His 1959 football team had a perfect 11-0-0 record. Another outstanding high school coach was James "Red" Jarrell, who compiled a 200-9 record during his 13 years as boys' basketball coach and later served as the county's superintendent of schools. (Courtesy of Winfred Carden.)

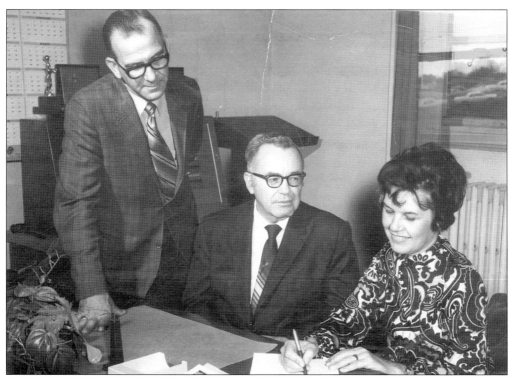

Shown in the photograph above, first published in the 1971 Coffee County High School annual, are, from left to right, Herman Massey, chemistry teacher who taught for 34 years in the Coffee County school system and also served as vice principal; Joe Frank Patch, who served 11 years in the county as a teacher and another 34 years as principal of the high school from 1941 to 1975; and Polly Sherrill Banks, who was the secretary from 1959 to 1975 and 1980 to 1985. Shown in the postcard below is the high school after renovations, including 13 additional classrooms and a new gymnasium, cafeteria, band room, and library. On August 29, 1976, a new comprehensive high school was opened on US Highway 55 south of town with Bobby Cummings as principal. His successor was Joe A. Brandon. (Below, courtesy of Ruth Banks Morton.)

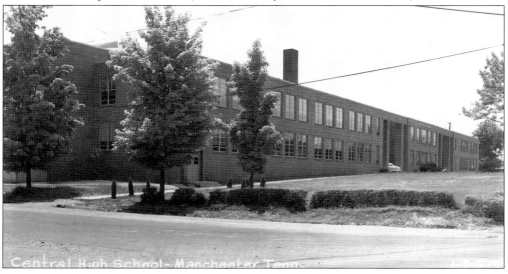

Central High School- Manchester Tenn.

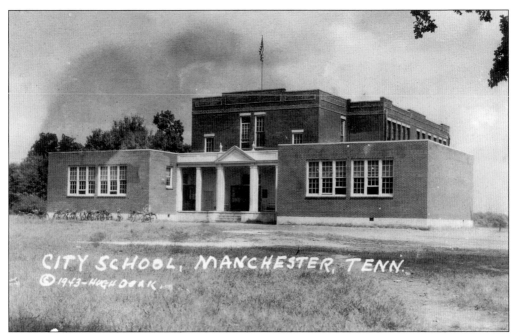

In 1915, the Manchester College changed its name to Manchester City School. The college had been a private school housing more than 250 students. The two-story brick building was remodeled and had an entrance on each side. In 1971, the building, located at College Street, was remodeled again. (Courtesy of Ridley Wills II.)

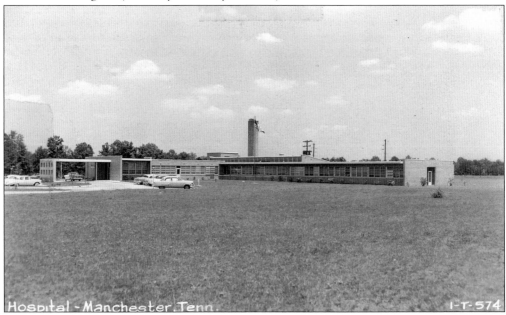

This hospital on the Manchester–Tullahoma highway was dedicated on February 21, 1954, on land donated by Grace and Heard S. Lowry Sr. Dr. Horace Farrar was chief of staff. His father was Dr. C.M.H. Farrar of Hillsboro. His sons, Howard and Clarence, were doctors in Manchester. Dr. Horace Farrar Day was celebrated on October 24, 1959. It was a county hospital until 2002. (Courtesy of Ruth Banks Morton.)

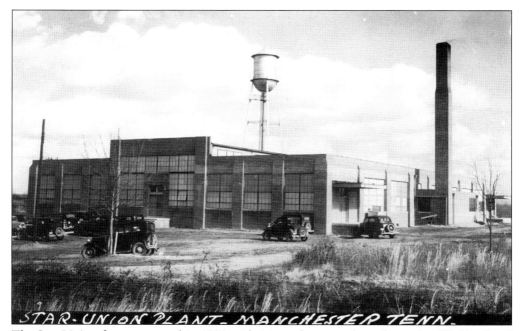

The Star Union factory opened in 1936 with 24 employees and was located at Highland and Coffee Streets. The plant manufactured sleepwear throughout the years and gave employment opportunities, especially to women across the county who sewed in the factory. Joe Baumstein was manager from 1936 until his retirement in 1968 and was succeeded by Leo Guy. In 1962, the company changed its name to Pajama Corporation of America.

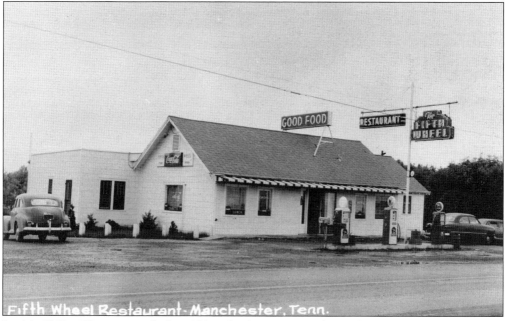

In this 1940s Cline postcard, the Fifth Wheel Restaurant, located on Highway 41 just south of town, proudly advertises good food. It opened in 1946 and was operated for many years by Lowell Finton "Red" Washam. The restaurant was a favorite not only of travelers, but locals as well. Note that the gas pumps outside offered ethyl gasoline.

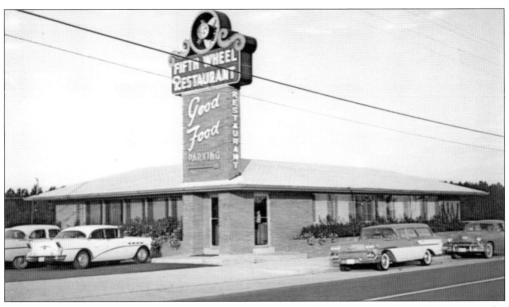

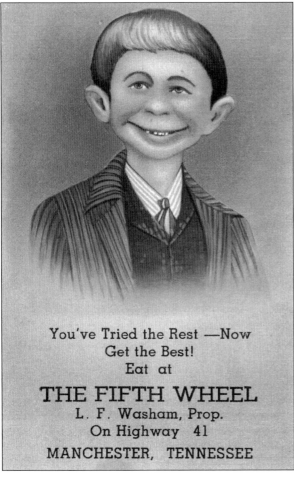

You've Tried the Rest —Now
Get the Best!
Eat at

THE FIFTH WHEEL
L. F. Washam, Prop.
On Highway 41
MANCHESTER, TENNESSEE

This postcard shows the renovated Fifth Wheel on Highway 41 in the late 1950s. Among the other restaurants and operators on this stretch were Jersi Joy, Henry B. Short (owner) and Adella C. Jernigan (operator); 41 Drive In, John "Buck" Hannah; Jiffy Burger, J.S. Pennington; Dairy Queen, George Gallagen; and the Glass House, Orien "Fats" McBride and later Felix Sowell.

Another version of publicity cards, this linen postcard, which probably served also as a souvenir for travelers who dined at the Fifth Wheel, has the message that proudly touts, "You've Tried the Rest—Now Get the Best!" This was a popular type of stock postcard used by businesses across the country. (Courtesy of Becky Haggard.)

Four

COUNTRY LIFE

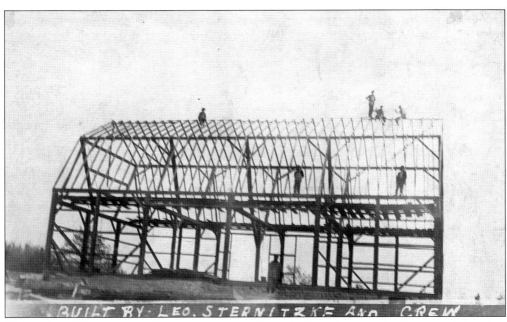

This early-1900s postcard shows the construction of a large barn as the framework is being completed by Leo Sternitzke and his crew. On the back of the card is the note, "near Manchester, Tenn." and "Conrad's barn." Today, century-old barns dot the countryside throughout the county. (Courtesy of Ridley Wills II.)

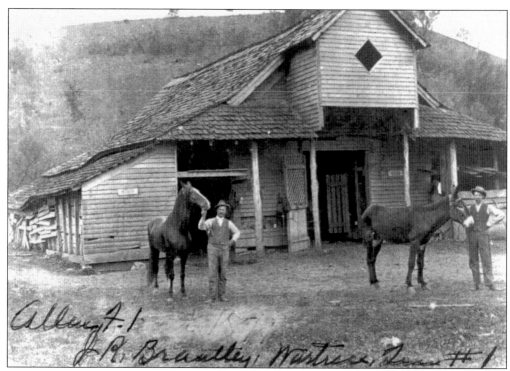

In the photograph above, taken on the Brantley farm in Noah, Allan F-1 is on the left held by James Ashley. To the right is a jack held by an unidentified man. In 1903, James R. Brantley purchased Black Allan, later known as Allan F-1, the foundation sire of the Tennessee Walking Horse. The American Saddle mare, Gertrude, was bred to Allan F-1 and produced a colt, Roan Allen F-38. The farm is now owned by Charles E. Brantley, who is James's grandson and the only Walking Horse breeder to be inducted into the Tennessee Sports Hall of Fame. The postcard below with unidentified buggy passengers has the name "Robt Farrell" written on back. (Above, courtesy of Charles E. and Nellie Brantley; below, courtesy of CC/M/T Museum, Inc.)

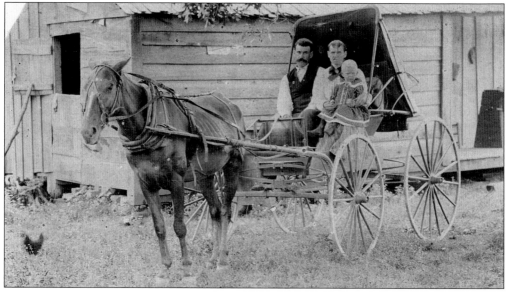

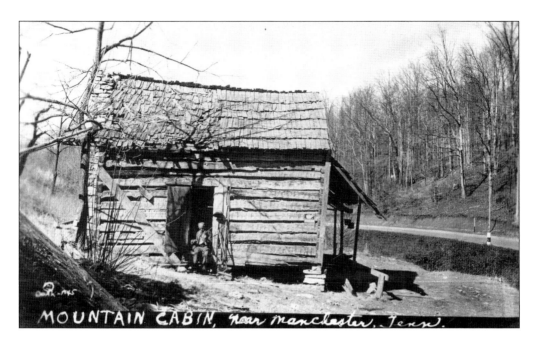

MOUNTAIN CABIN, near Manchester, Tenn.

These two real-photo postcards made by Doak in the 1940s show a stretch of old Highway 41 as it makes it way down Matt's Hollow about six miles northwest of Manchester. In the late 1930s, the highway was changed to the left of Matt's Hollow. After the route changed, travelers missed seeing the unidentified man playing his fiddle in the doorway to his cabin as pictured in the card above. The message on the back of the postcard below is from Cpl. V.L. Voeller and postmarked from Camp Forrest on March 10, 1943, to his mother and father in Columbus, Ohio. It reads: "Are we in the hills? We are in the hills." Note the wooden footbridge.

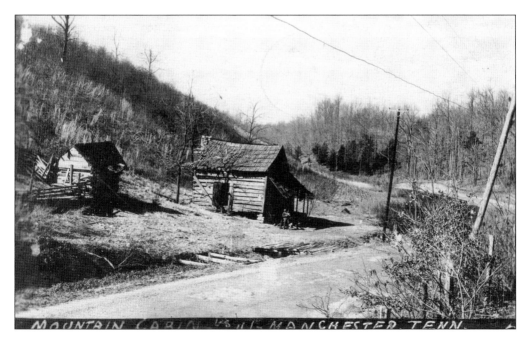

MOUNTAIN CABIN, MANCHESTER, TENN.

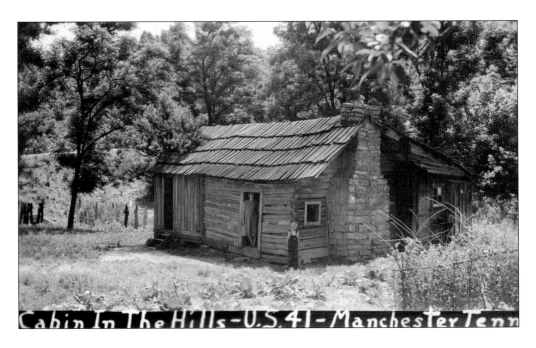

[Handwritten postcard. Reading of visible text:]

Dear Folks: 4/20/43 Cpl Daniel B. Stevens 36 505 201 — L 314 Inf — People actually live in cabins like this one here and [...] all through these hills. It is as common a type of dwelling as any. We had classes in the sports arena all day today except for an outdoor [...] flag demonstration out on a parade ground. We finish up tomorrow and get our assignments to the companies that we are to [...] throughout the maneuvers. Probably we will move out Thursday. Your son Daniel

Mr & Mrs H B Stevens
905 Maffett Street
Muskegon Heights
Michigan

Nashville, Tenn.

Pictured above is the back of the postcard mailed from Camp Forrest in April 1943. The message is from Cpl. Daniel B. Stevens to his parents in Muskegon Heights, Michigan. The front of the postcard, shown below, is the cabin in the hills that Stevens refers to in his message. The unidentified woman and boy posed for the photographer. Note the laundry hanging on the line beside the cabin. This cabin was located at the end of Matt's Hollow Road where the old Highway 41 ran near Noah. The July 21, 1939, *Manchester Times* front-page story was that the highway between Manchester and Nashville had been completely paved with concrete.

Cabin In The Hills - U.S. 41 - Manchester Tenn

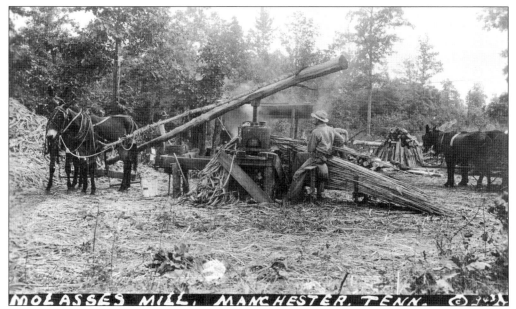

In this 1940s real-photo postcard, Doak captured unidentified men hard at work making sorghum molasses. One of the best-known farmers to make the prized sweet product was Robert Deberry, who established one of the first sorghum mills in the northern part of Coffee County near Shady Grove. His son Middleton later helped with running the molasses mill.

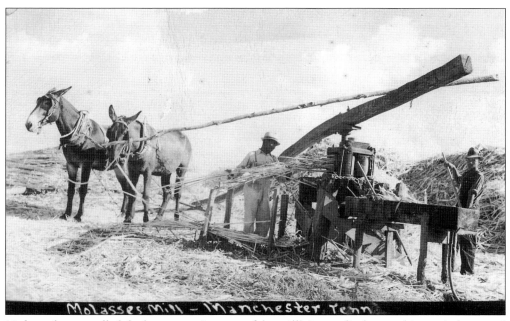

Mules or horses pulled the long sweeping arm of the mill's iron cylinders, making a circle around the mill as cane stalks were hand-fed so juice could be caught and then cooked. An article in the October 15, 1937, *Manchester Times* recognized Joe May as one of the leading manufacturers of sorghum molasses, producing as much as 100 gallons per acre of sugar cane. (Courtesy of Ridley Wills II.)

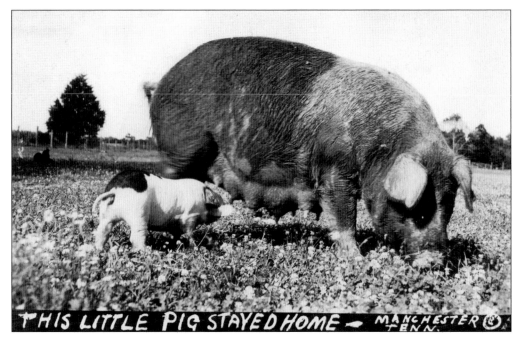

When Doak photographed these sows and piglets in the 1940s, he was having fun, as evidenced by the titles *This Little Pig Stayed Home* and *Country Hams Grow at Manchester, Tenn.* One of the major hog raisers in the county was Lennie Freeman Stepp from the Noah/Beech Grove community, who started his business in 1955 and was joined by his sons Doyle, Max, and Bobby. They operated a 1,200-acre farm that could accommodate more than 400 hogs. Throughout the years, the Stepps made their Yorkshire and Hampshire hogs world famous through sales and advertising. According to the 1970 census, there were 300 Coffee County farmers raising hogs and earning more than $1.5 million in sales.

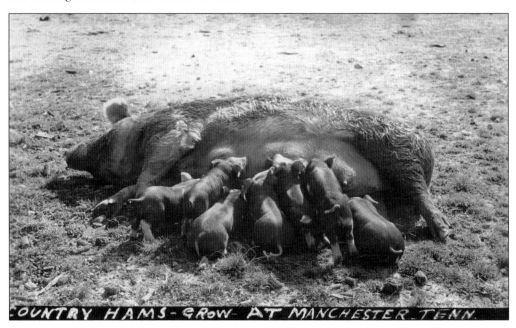

Above, this ornate postcard with a glittered greeting from Beech Grove was postmarked in 1909. Located about 14 miles northwest of Manchester, Beech Grove became the site in 1866 of one of the first Confederate cemeteries in the South. Some popular businesses included Glen Underwood's grocery and filling station, once operated by Mervin Ferrell; Brown's Grocery, once operated by Fred W. Elmore; Garcia Parker's grocery; and Mary Hill's Café. David Jacobs, Coffee County historian and educator, was a native of Beech Grove. Many linen postcards were sent similar to the one below, which showcases the agricultural richness of the communities around Manchester. (Above, courtesy of Ridley Wills II; below, courtesy of Pete Jackson.)

GREETINGS FROM MANCHESTER, TENNESSEE

The embossed postcard above sends greetings from Belmont, located between Manchester and Tullahoma near US Highway 55. Other nearby communities include Hickerson Station and Rutledge Falls. Manchester was known as the "cross-tie capital of the world" because millions of ties were shipped from Black Jack Switch in the Belmont community. (Courtesy of Ridley Wills II.)

"SPEARS CABIN" Don Northcutt COFFEE COUNTY, TENNESSEE

This postcard depicts Don Northcutt's drawing of the Spears cabin in Ninth Model. Northcutt was a technical illustrator for Arnold Engineering Development Center and served as county commissioner for 20 years. Among the county landmarks that he captured in his drawings was Phelps Grocery in the Gnat Hill community. (Courtesy of Carolyn and Mike Northcutt.)

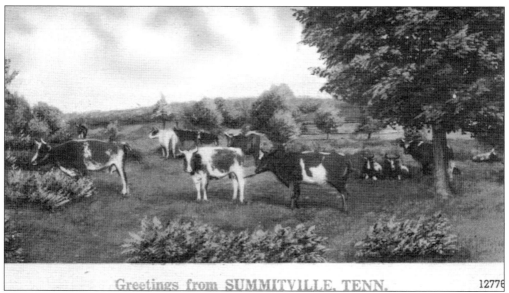

These two postcards represent communities that are rural areas. In the 1930s and 1940s, dairy farming grew. Farmers would put milk into cans for pickup to be delivered to town. The milk was taken to the cheese factory, Carnation Milk Plant, or later to the Jersey Gold Plant operated by Henry Short. Today, 12 Coffee County farms have been named century farms because they have been owned and worked by a family for more than 100 years. They include the Claude Anderson farm in Noah; Beckman farm in Summitville; the Brown dairy farm in Hillsboro; the Carden ranch in Noah; the Couch-Ramsey farm in Summitville, the Freeze farm in Summitville; the Homestead farm in Viola; the Jacobs farm in Beech Grove, the Long farm in Hillsboro; the Shamrock farm in Cheatham Springs; the Sunrise View farm in Asbury; and the Thomas farm in Noah. (Both, courtesy of CC/M/T Museum, Inc.)

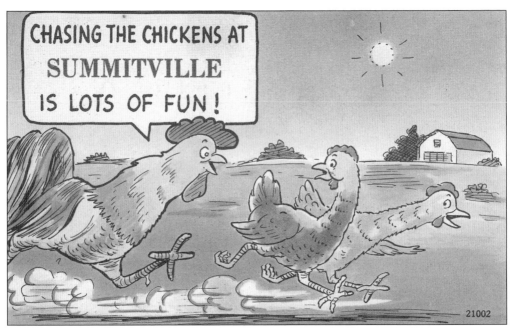

This humorous postcard conveys that chasing chickens at Summitville, seven miles northeast of Manchester, was lots of fun. Summitville was the home of a successful poultry business that the prosperous community enjoyed starting in the early 1900s as it became a large poultry shipping point for the county. (Courtesy of Ridley Wills II.)

Summitville offered up many tranquil scenes like the one with the deer in this postcard. However, it was also a bustling place of business. F.F. Jackson and Son operated a produce and general store. In the early 1900s, the Tennessee Cement and Lime Company produced lime that was shipped out in train cars daily from Summitville. The lime was largely used for sugar refining in Louisiana and Cuba and in purification of water in New Orleans. (Courtesy of Peggy McColloch.)

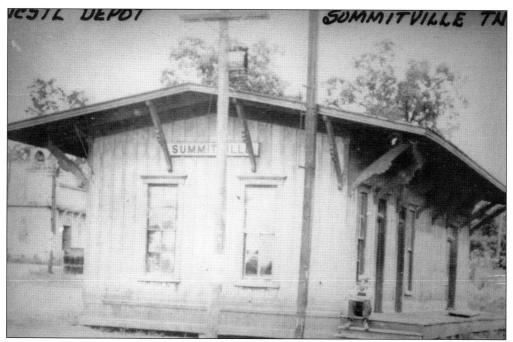

Summitville was established in 1855, receiving its name because it is the highest point between Manchester and McMinnville. The railroad ran through Summitville. The S.L. Rigney store, which opened in 1905 and closed in 1975, faced the railroad tracks and housed the post office. Powers and Banks general store was another popular business. (Courtesy of Tennessee State Library and Archives.)

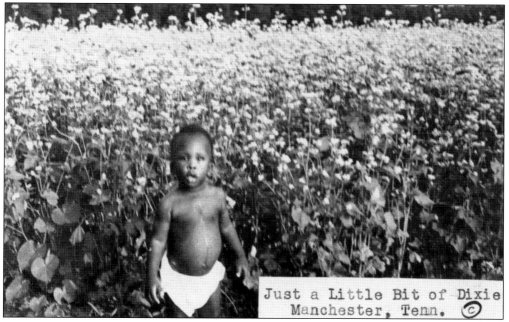

This postcard captures an unidentified child at play in a cotton field. This scene appeared on the front page of the *Manchester Times* on October 17, 1947. Some of the leading cotton farmers at this time were from Hillsboro, including R.G. Winn, T.R. McCormick, and W.M. Lassater.

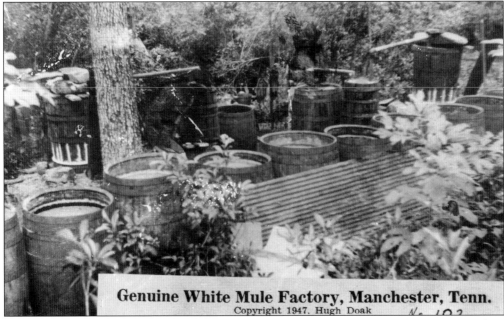

Genuine White Mule Factory, Manchester, Tenn.
Copyright 1947, Hugh Doak

These two real–photo Doak postcards from 1947 show two different views of a "Genuine White Mule Factory." Moonshine is said to get its name from the fact that moonshine producers and smugglers would often work at night under the light of the moon. The term "white mule" was a reference to the brew's lack of color and that it gave a kick when consumed. The county has also had several legal distilleries, including the Farrar Distillery in Noah. Alexander Farrar established the distillery in the 1870s, producing and selling corn whiskey and apple and peach brandy. It operated until 1902 and is now known as the Thomas farm. The distillery is listed in the National Register of Historic Places.

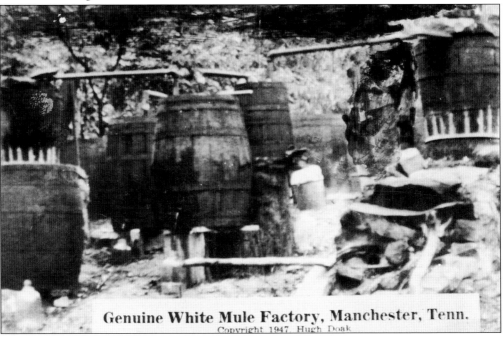

Genuine White Mule Factory, Manchester, Tenn.
Copyright 1947, Hugh Doak

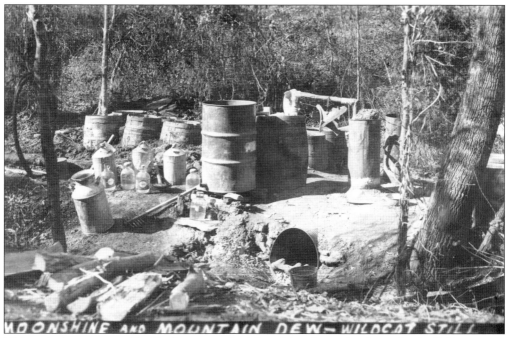

This real-photo postcard by Doak, postmarked from Manchester in November 7, 1942, was sent to Minesville, New York. "Mountain dew" was a common name given to the bootleg liquor because it was often made from running mountain water. This postcard scene was on display at the Moonshine and the Law exhibit at the Tennessee State Library and Archives in 2013.

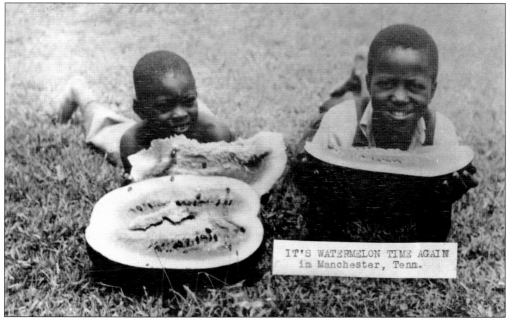

Two unidentified youngsters enjoy eating watermelon the old-fashioned way in a photograph that shows a summer treat that always brings a smile. Some of the best vegetables and fruits grown in the county are on display every September at the Coffee County Fair, which started in 1857 and at one time was billed as the oldest free county fair in the country.

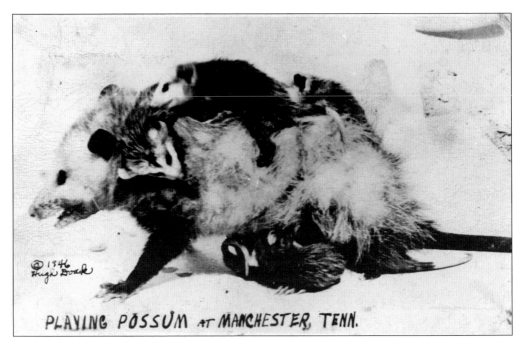

PLAYING POSSUM AT MANCHESTER, TENN.

The Manchester area has always been plentiful with wildlife, including opossums, Tennessee's only marsupial or pouched animal. In the card above, Doak photographed this mother opossum with her young in 1946 to produce a whimsical postcard. Almost everyone has either said or heard the expression "playing possum," which refers to someone pretending to be asleep. The North American opossum actually does pretend to be dead and even sometimes may pass out when a predator approaches. In the card below, photographer Cline captures the young catching a ride on their mother opossum's back as they travel US 41. This postcard traveled to a recipient in Fort Sills, Oklahoma.

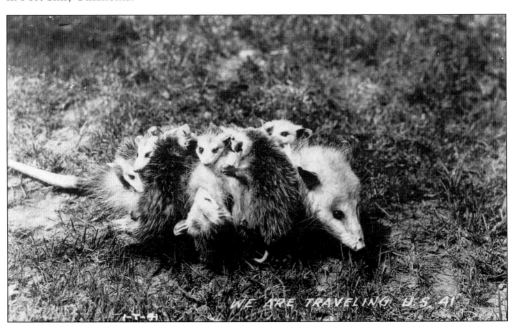

WE ARE TRAVELING U.S. 41

Five

SCENIC ROADS
AND VIEWS

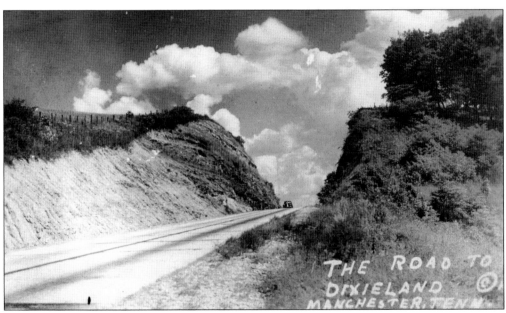

This postcard is of one of the most popular scenes Doak photographed that was marketed to Highway 41 travelers and to soldiers stationed here in the 1940s. Located in Noah, also known as Needmore, the scene is almost 10 miles northwest of Manchester. The postcards of this stretch of the road had different titles, including *Road to Dixieland, Gateway to the Highland Rim*, and *The Big Cut*.

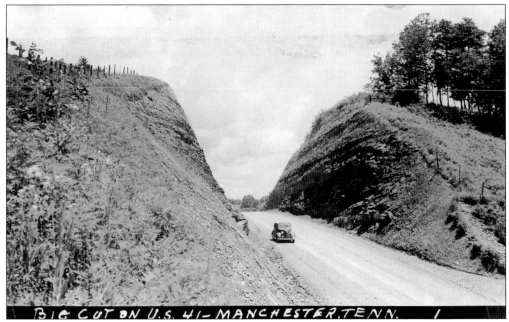

Noah residents often referred to the passage above as the Big Cut, as did Doak when he entitled this early view of the engineering feat that led Highway 41 through the hillside. Many man-hours were needed to move the rock and dirt to make the 70-foot passage. This view, marked as "1," shows a car headed north toward Murfreesboro.

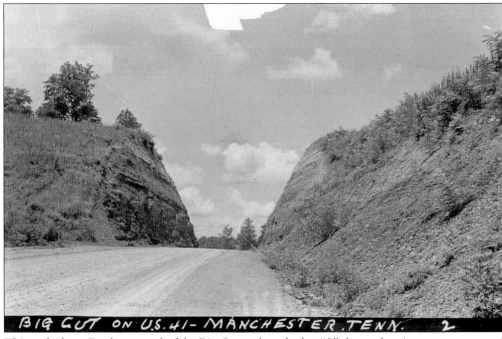

This real-photo Doak postcard of the Big Cut and marked as "2" shows the view as one emerged from the passage headed south. According to David Hickerson, his grandfather, Lillard Hickerson, was the person who set the dynamite charges to blast away the rock for the passage to be made through the hill.

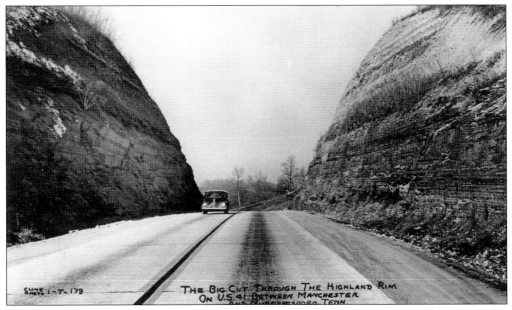

Cline captured this scene of the Big Cut in the 1940s, and lingering snow can be seen on the cliff. The car is headed south toward Manchester. Highway 41 formerly ran just over the hill to the left along the creek, site of the Cheatham Springs farm, once owned by Confederate general Benjamin Franklin Cheatham. His horse, Old Isham, is buried next to the road.

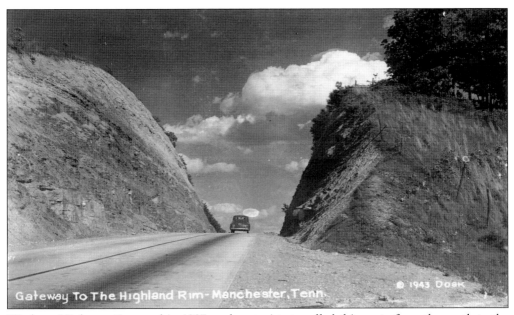

Work on Highway 41 started in 1937, and motorists travelled this route from the north to the south for many years. As can be imagined, there was a lot of congestion and frequent wrecks, as an estimated 15,000 vehicles traveled the route daily. It was not unusual to see a front-page story on the *Manchester Times* about such wrecks.

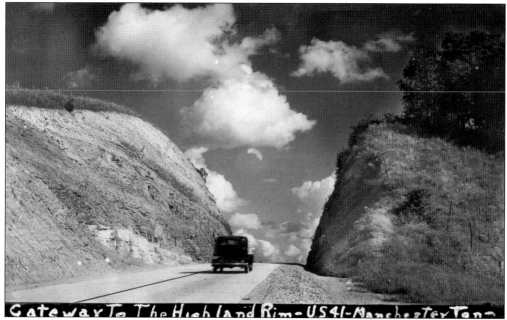

When Interstate 24 was completed between Murfreesboro and Manchester and there was less traffic travelling on Highway 41, the *Tennessean* newspaper had a photograph on the front page showing the sweeping view and farmland of the valley below. The headline stated that motorists would miss this view as they emerged from the cut headed toward Manchester.

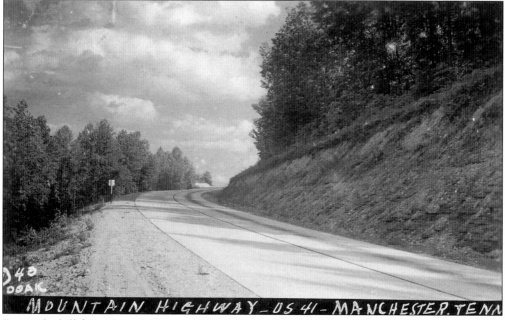

Down the hill from the cut was a grocery store, no longer there, which was operated by several men, including John Daniel McCollough, Jess Brandon, and Harold Munsey. Farther down is Stepp's Store, no longer open but now owned by Marvin Stepp. His grandfather, William Obie Stepp, started the business in a nearby location in 1902. Marvin joined his father, Ewin, in 1952 in the store. (Courtesy of Becky Haggard.)

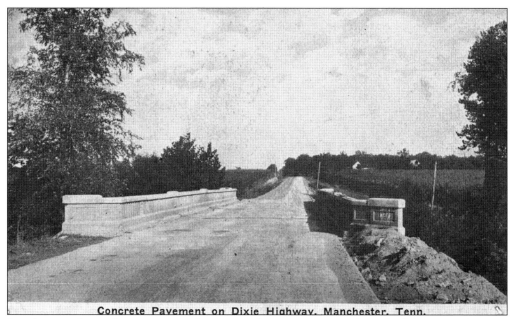

Concrete Pavement on Dixie Highway. Manchester. Tenn.

Roads around Manchester improved in 1924, when a concrete road was built between the town and Hillsboro. Later, a five-mile stretch of concrete road was completed heading out of town toward Beech Grove and ending near the Horace Teal farm. Prior to that, the County Highway Commission bought field rock from landowners to use for road construction. (Courtesy of Ruth Banks Morton.)

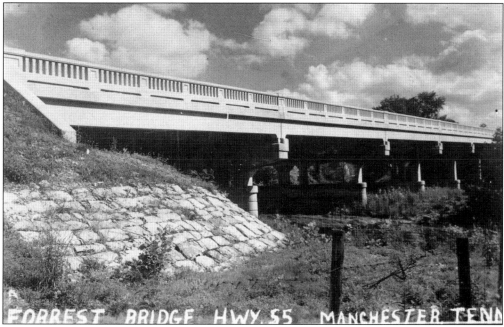

FORREST BRIDGE HWY 55 MANCHESTER TENN

A new road from Tullahoma to Manchester was started in 1941. The road, now Highway 55, runs from Moore County through Tullahoma, Manchester, Summitville, and on to Warren County. The Forrest Bridge, shown in the postcard above, still stands and is located near the College Street School. It crosses over the Little Duck River.

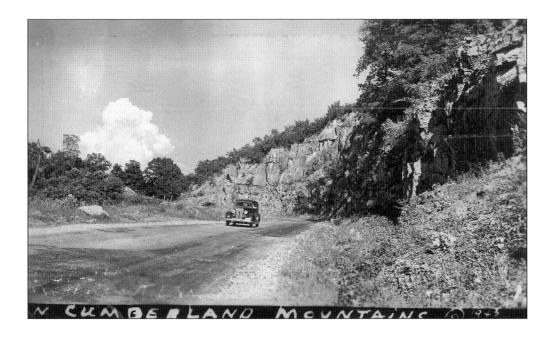

These two early Doak postcards show the Dixie Highway as it had been cut and paved through the Cumberland Mountains. Motorists have always discovered that crossing the Cumberland Plateau as one leaves the Manchester area and heads toward Monteagle is one of the most hazardous stretches of road in the country to maneuver. Note the large rock boulders in the cliff overlooking the road. From the early days of the Dixie Highway to today with the Interstate 24 highway, it is a journey that demands caution. Note the house that is close to the road in the postcard below. (Above, courtesy of Ruth Banks Morton.)

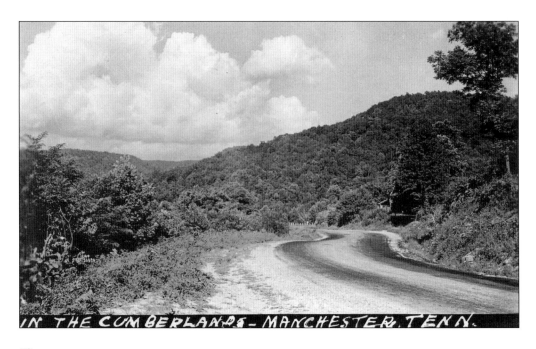

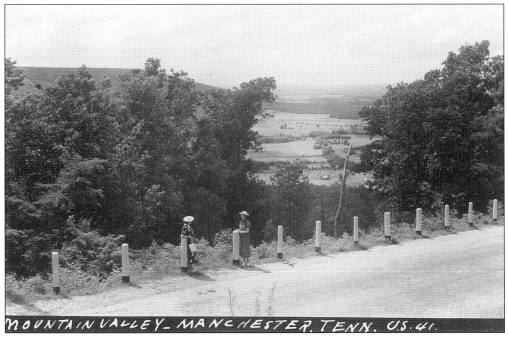

Two unidentified women standing by the road posts stop to enjoy the breathtaking panorama of the mountain valley. This scene between Manchester and Monteagle Mountain has been dubbed "the million-dollar view." Motorists would stop, when possible, to enjoy and perhaps take photographs as souvenirs of their trip. (Courtesy of Ridley Wills II.)

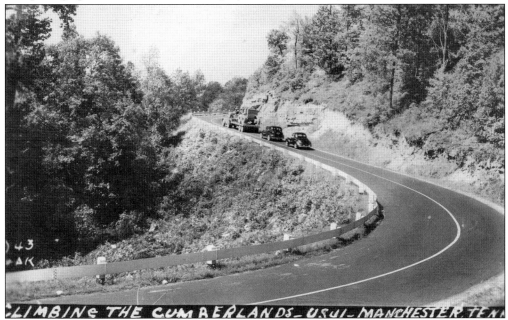

The challenging drive up the Cumberland Mountain on Highway 41 became even more so when traffic included a large truck like the one shown carrying heavy construction equipment. At approximately 2,000 feet above sea level, nearby Monteagle Mountain is the highest point between Chicago and Miami on US Highway 41.

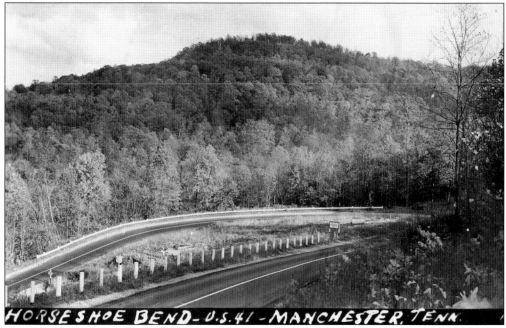

HORSESHOE BEND-U.S.41-MANCHESTER, TENN.

The drive up Cumberland Mountain on Highway 41 was beautiful because the plateau contained some of the largest stretches of contiguous forest in the eastern United States. However, places like the one in the above Doak postcard of Horseshoe Bend show the challenge of driving it. As can be seen in the postcard below, bus travel was a popular mode of transportation. This bus is making the treacherous trip around the Horseshoe Bend on Highway 41 after train passenger cars were no longer available. A bus line made two trips daily from Hillsboro to Manchester, and another line operated daily between Manchester and Tullahoma. In Manchester, Coy St. John was manager of the Greyhound bus station from 1941 to 1944. Arnold Bus ran between Manchester and Woodbury from 1945 to 1961.

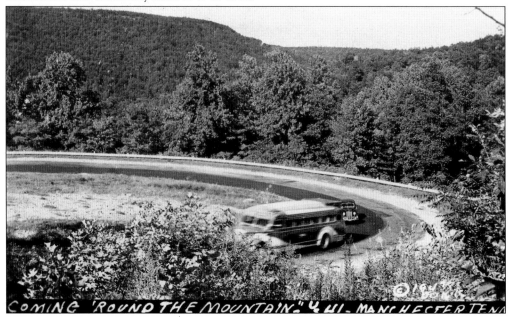

COMING 'ROUND THE MOUNTAIN." U.41. MANCHESTER TENN

Six

THE DUCK RIVER, LAKES, AND WATERFALLS

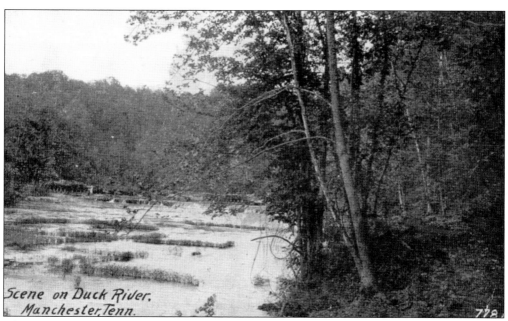

Scene on Duck River, Manchester, Tenn.

This real-photo postcard sent in 1913 shows an early scene on the Duck River near Manchester. The Duck River, approximately 270 miles long, is entirely within the state of Tennessee. It begins in the Eastern Highland Rim, crosses the Central Basin, flows west across the Western Highland Rim, and merges with the Tennessee River.

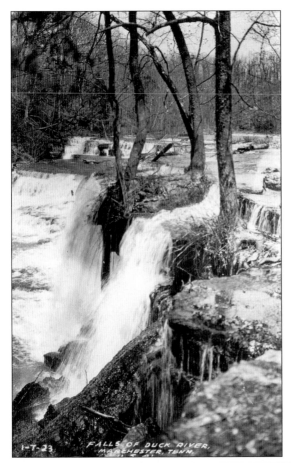

These two real-photo postcards show Blue Hole Falls on the Duck River in the Old Stone Fort State Archaeological Park. The waterfalls from the Duck River have provided a great power source for Manchester. This inspired the founders of the town of Manchester to name it after the great industrial city of Manchester, England. In the town's earlier years, the Duck River supplied power for a Civil War gunpowder mill, a rope factory, sawmills, gristmills, cotton gins, and paper mills. This manufacturing spirit later resulted in various industry-based businesses near Manchester, including the Carnation Milk Company, the Hough Drug Company, Reid Hosiery Mill, Star Union, Sain Construction Company, Batesville Casket Company, and the Tennessee Cement and Lime Company.

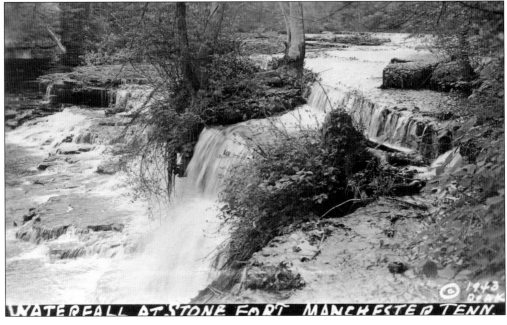

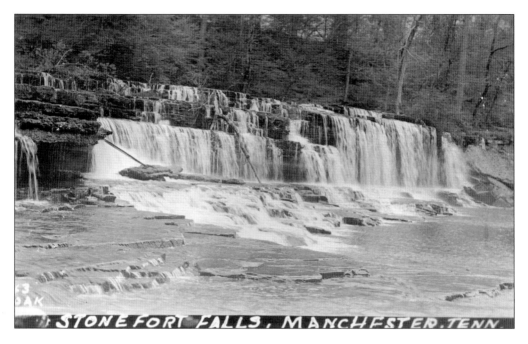

The postcard above shows a waterfall in the Old Stone Fort State Archaeological Park, which is a 2,000-year-old American Indian ceremonial site. About 50 acres of land is enclosed by the forks of the Duck River and by walls. Archaeologists believe this was a ceremonial site built by Woodland Indians, as there is no evidence of permanent habitation. The photograph below shows Gov. Frank G. Clement and his family. From left to right are Robert "Bob" Clement, James Gary Clement, Governor Clement, Lucille Clement, and Frank Clement Jr. On April 23, 1966, Clement dedicated the 468 acres in and around the fort as a state park. John Chumbley, who owned the land prior to the State of Tennessee, was instrumental in preserving it by refusing development of the land. (Below, courtesy of CC/M/T Museum, Inc.)

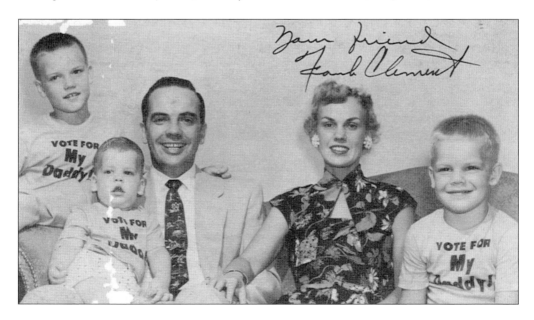

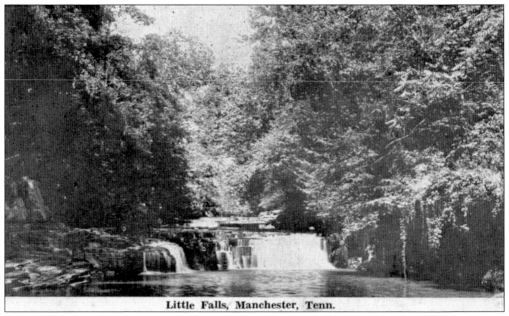

Little Falls, Manchester, Tenn.

Little Falls, also known as Step Falls, is a series of waterfalls located in the Old Stone Fort State Archaeological Park on the Little Duck River or Bark Camp Fork, one of the two main tributaries of the Duck River. The Little Duck River drains from the northeastern areas near Ragsdale, across Highway 41 in the southeastern area and westward through Manchester, then joins the Big Duck River at Old Stone Fort.

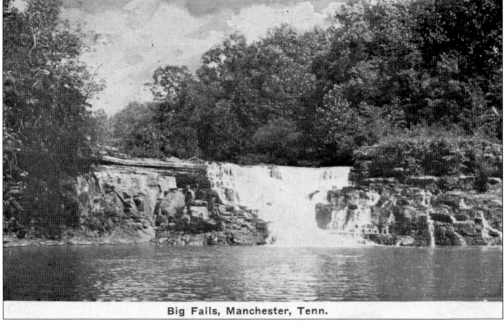

Big Falls, Manchester, Tenn.

Big Falls is located in the Old Stone Fort State Archaeological Park on the Big Duck River or Barren Fork tributary of the Duck River. It has the most abrupt vertical drop of all the falls in the park, creating deep pools along the bottom of the falls that abound with many varieties of fish. The wall of the Old Stone Fort begins above these falls.

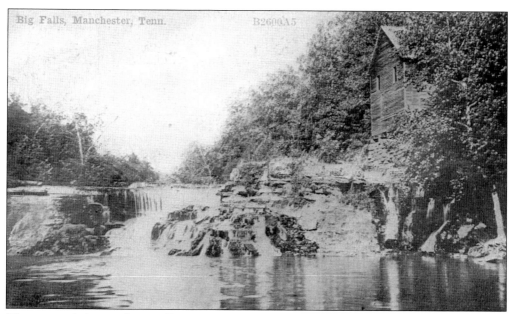

The postcard above of Big Falls, postmarked in 1910, depicts one of the last buildings of the Stone Fort Paper Company mill, which opened in 1879 along the Big Duck tributary of the Duck River. By 1880, the mill, operated by William P. Hickerson Jr. and Fannie Wooten, was producing thousands of pounds of paper daily. Two mills produced paper for newspapers, including the *Nashville Banner*, *Atlanta Constitution*, and *Memphis Commercial Appeal*, while another mill produced brown wrapping paper. These mills produced a town in itself, including a commissary and boardinghouse. The building shown in the postcard above was later washed away in a flood, as seen by a later view of Big Falls in the real-photo postcard below, in which an unidentified individual is overlooking the falls. (Above, courtesy of Pete Jackson.)

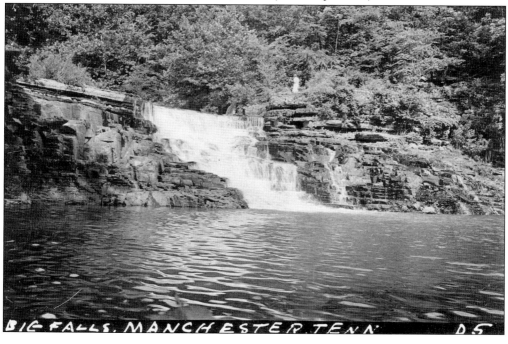

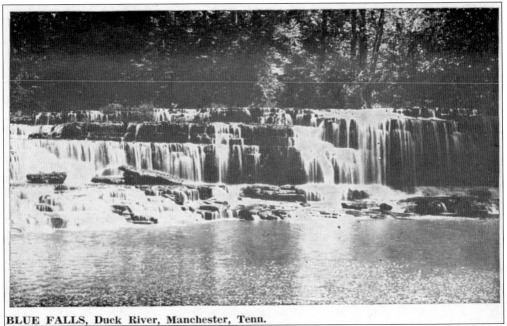

BLUE FALLS, Duck River, Manchester, Tenn.

Blue Hole Falls is the first major falls on the Big Duck or Barren Fork, one of the two main tributaries of the Duck River in the Old Stone Fort State Archaeological Park. The Big Duck River begins near Gnat Hill and flows southwesterly toward the Goose Pond area. It continues to flow in a southwest direction until it joins the Little Duck River at Old Stone Fort.

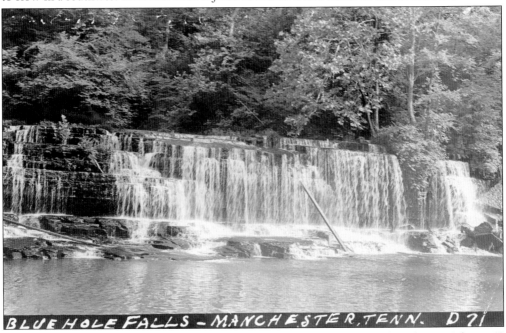

BLUE HOLE FALLS - MANCHESTER, TENN. D 71

This real-photo postcard of Blue Hole Falls sent in 1938 depicts what travelers along Highway 41 through Manchester felt about the atmosphere surrounding them. The sender of the card states, "Dear Dad, Am on a trip down here where the peanuts and cotton grows. Wish you were here to enjoy the country with me."

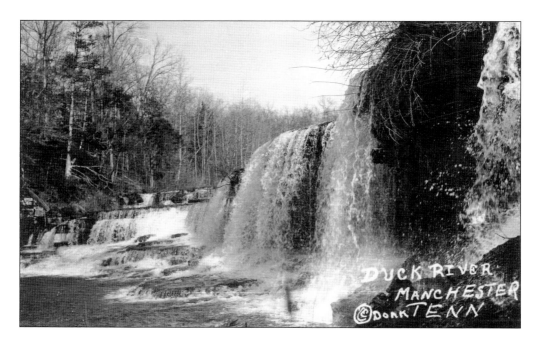

These real-photo postcards show scenes along the Duck River. The sender of the postcard above, sent in 1947, describes this as "A very pretty little place." There are many scenic spots such as these along the Duck River flowing through Manchester and through nearby communities. Many of the Duck River's tributaries are fed mostly by springs. Some of these include Bashaw Creek, Bray Branch, Brewer Creek, Eaton Branch, McBride Branch, Muddy Branch, Norton Branch, Riley Creek, Taylor Branch, Wisers Branch, and Wolf Creek. The Big Duck and Little Duck Rivers, two forks of the Duck River, converge at Old Stone Fort State Archaeological Park.

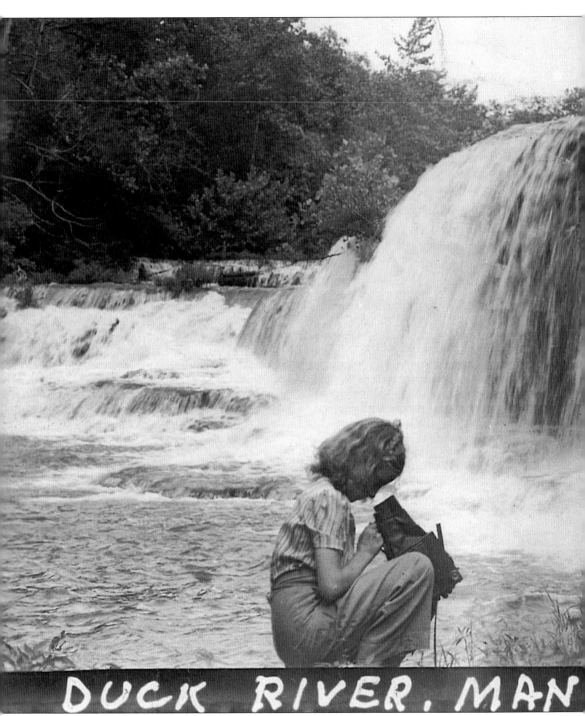

DUCK RIVER, MAN

This real-photo postcard was taken by Hugh Doak and sent in 1943. It shows three unidentified girls enjoying the Blue Hole Falls on the Duck River. The Duck River is a beautiful natural resource and also home to a diversity of freshwater animals. The Tennessee Wildlife Resources Agency has designated the river as a mussel sanctuary. The rare birdwing pearly mussel exists only in great numbers in the Duck River. A small catfish named the pygmy madtom is found

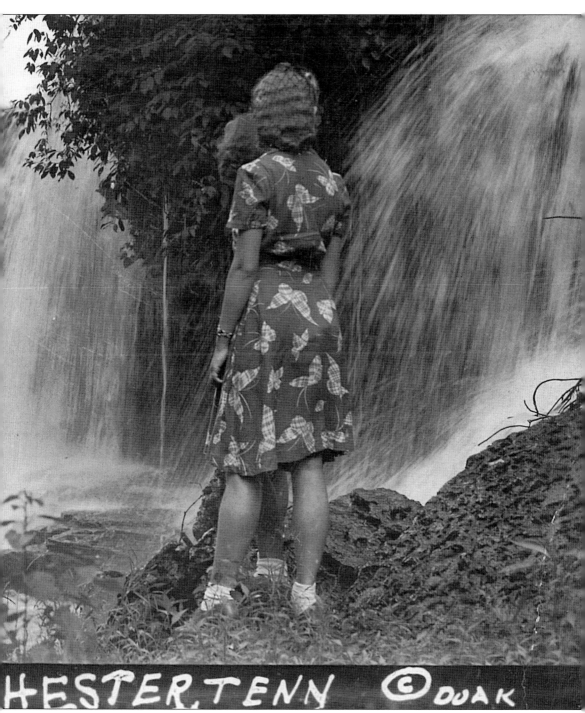

HESTER TENN ©DUAK

only in the Duck and Clinch Rivers. Most of the Duck River is free flowing, with only one impoundment near Manchester at TVA's Normandy Dam, built in 1976 to create the Normandy Reservoir. This free-flowing nature of the Duck River and the many years that it has been flowing have created an ideal atmosphere in which these rare species can thrive.

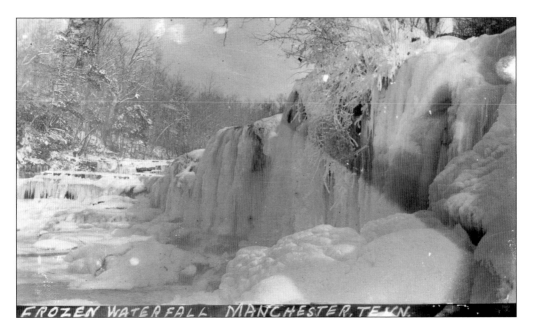

FROZEN WATERFALL MANCHESTER, TENN.

The real-photo postcard above, taken by Hugh Doak, shows the ice formations at Blue Hole Falls in the Old Stone Fort State Archaeological Park when it was frozen over during one of Manchester's harsh winters in January 1940. Some of the harsher winters during that time include 1937, 1940, 1947, and 1951. According to a 1980 issue of the *Manchester Times*, Clark Willis, nephew of Hugh Doak, remembered that day vividly, as he recounted that he fell into the chilling unfrozen pool under these falls the day this photograph was taken. This photograph captures the falls standing still. The real-photo postcard below shows a similar view of the waterfall in milder weather.

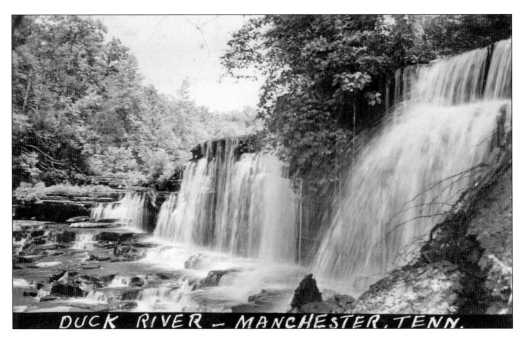

DUCK RIVER — MANCHESTER, TENN.

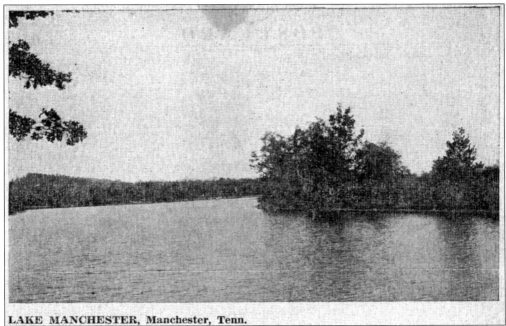

LAKE MANCHESTER, Manchester, Tenn.

Manchester Lake or Mill Pond, which later became known as Morton's Lake, was owned in its earlier years by Jonah Mills. The lake was originally used to provide power to a flour mill that washed away in a flood in 1902. Since the early 1900s, many power companies have generated electricity here. In 1915, the Tennessee Power Company operated here; in 1916, it was renamed the Public Light and Power Company. In the 1920s, the Southern Cities Power Company took ownership. John Chumbley later took ownership of the lake and repaired the dam. Under Chumbley's ownership, the lake was not open to the public for fishing. Chumbley later sold it to Bowlin Morton, resulting in the recreational Morton's Lake. (Below, courtesy of Ridley Wills II.)

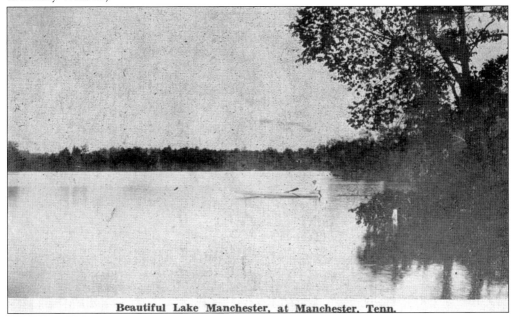

Beautiful Lake Manchester, at Manchester, Tenn.

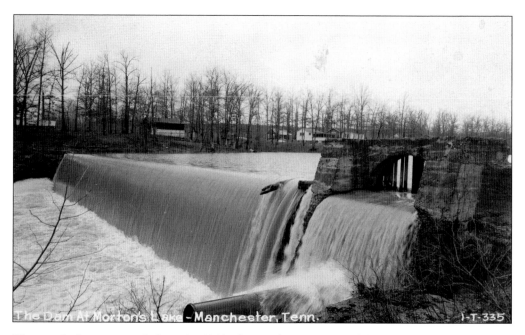

The Dam At Morton's Lake - Manchester, Tenn. 1-T-335

These real-photo postcards from the 1940s show a close-up view of the dam at Morton's Lake. In the 1920s, the Southern Cities Power Company, which supplied electricity to Manchester, had stations in Manchester, Summitville, Viola, and Tullahoma. This power company had a dam on the Duck River at Mill Pond, later known as Morton's Lake. Eventually the town of Manchester grew larger than the dam's capacity. Many people enjoyed being photographed on the flume of this dam, which was the chute that carried the water. Note the houses in the background. Many individuals have fond memories of hearing the water flow at the dam. (Below, courtesy of Ridley Wills II.)

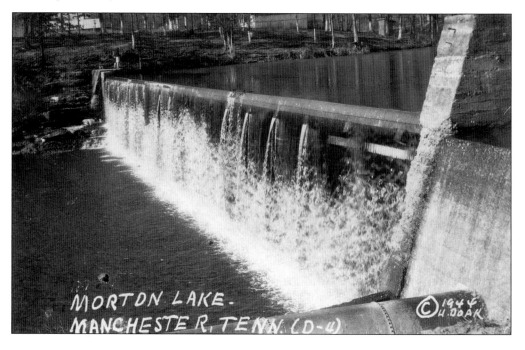

MORTON LAKE.
MANCHESTER, TENN. (D-4) © 1944 DOAK

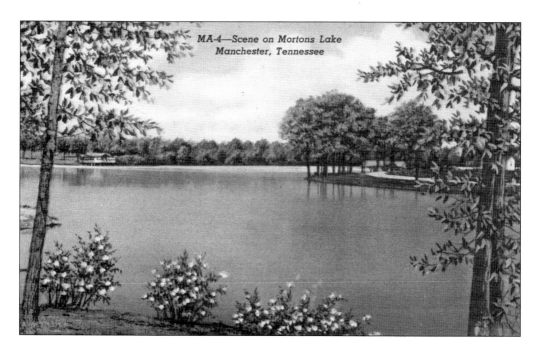

MA-4—Scene on Mortons Lake
Manchester, Tennessee

In 1939, Bowlin Morton bought Manchester Lake from John Chumbley. Since that time, the lake has been known as Morton's Lake. It is located one mile north of Manchester off Highway 41. Morton made many improvements to the property, including repairing the dam, which was broken during a flood in 1937. The dam is shown in the real-photo postcard below. He also raised the height of the dam, thus enlarging the area for fishing. After this improvement, the lake encompassed 101 acres. Morton opened the lake to the public for fishing in 1941. (Above, courtesy of Pete Jackson.)

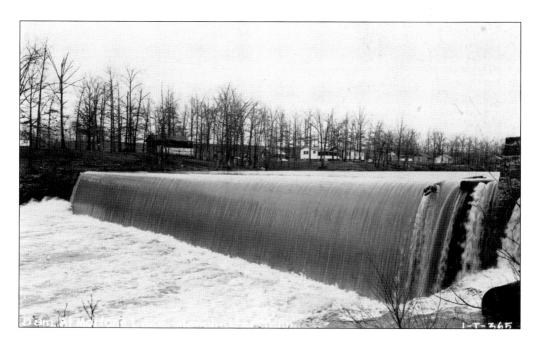

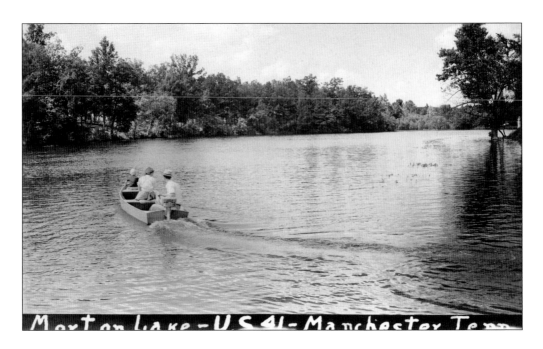

These real-photo postcards show unidentified individuals in boats on Morton's Lake. The postcard above shows a family going out for a day on the lake. The lake provided a paradise for local fishermen. Some of the individuals known to enjoy fishing in the area included Verland "Doc" Jernigan, Morgan Jernigan, Aubrey Ogles, Frank Jacobs, Bowlin Morton, Jim Henley, Pat Murchison, Hobart Brewer, Homer Rogers, and Roy Barber. Verland Jernigan provided hunting and fishing information in his outdoor columns in the *Manchester Times.* The postcard below shows a group of fishermen resting under the shed of one of the boathouses at the lake, while another fisherman is returning to the shed. (Below, courtesy of Pete Jackson.)

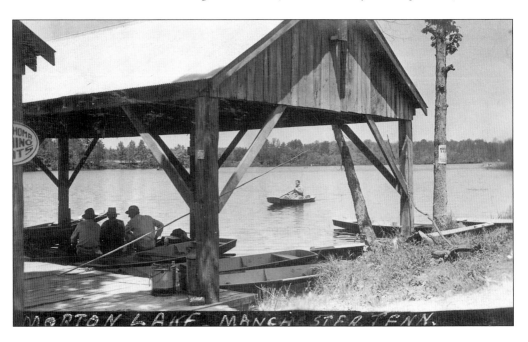

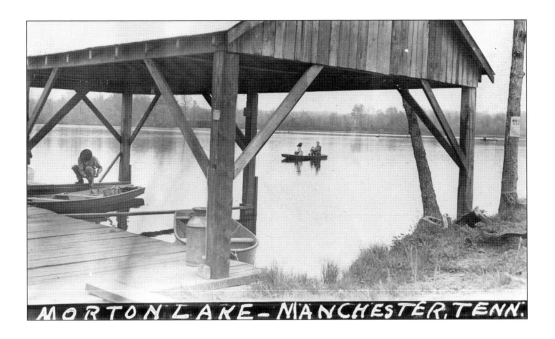

MORTON LAKE-MANCHESTER, TENN.

The real-photo postcard above shows unidentified individuals in and around one of the boat sheds at Morton's Lake. A couple is leisurely boating, while a fisherman is working near his boat. Bowlin Morton made many additions to the lake, including adding bathhouses, cabins, and boathouses. He also constructed a dock on the south side of the lake, which is shown in the real-photo postcard below with numerous boats tied up at the dock. He also created catchy advertising slogans that were printed in the *Manchester Times* to entice fishermen, including "They're really bitin' " and "Fishing is good at Morton's Lake."

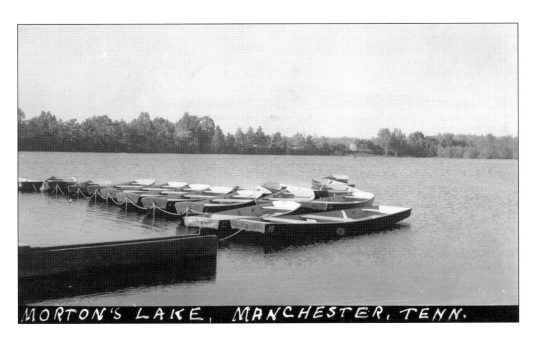

MORTON'S LAKE, MANCHESTER, TENN.

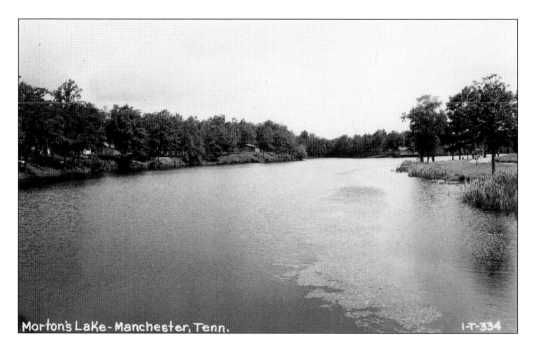

Morton's Lake - Manchester, Tenn. 1-T-334

During some of Manchester's harsher winters, Morton's Lake has provided additional recreational activities other than fishing and boating. There are stories about people driving over Morton's Lake when it was frozen. In 1937, according to Basil McMahan, Morgan Jernigan and Red Miller drove across the lake in a stripped-down Chevrolet. In 1977, this adventure was repeated by Robert Smartt and John Blackburn as they also drove their stripped-down Chevrolet across the lake. The local youngsters have also enjoyed ice-skating on the lake while it was frozen over. Many Manchester residents have fond memories of Morton's Lake from their childhood.

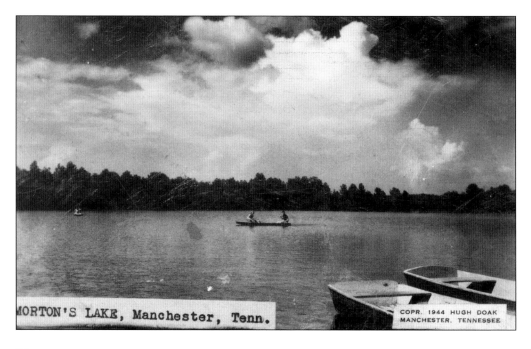

MORTON'S LAKE, Manchester, Tenn. COPR. 1944 HUGH DOAK
 MANCHESTER, TENNESSEE

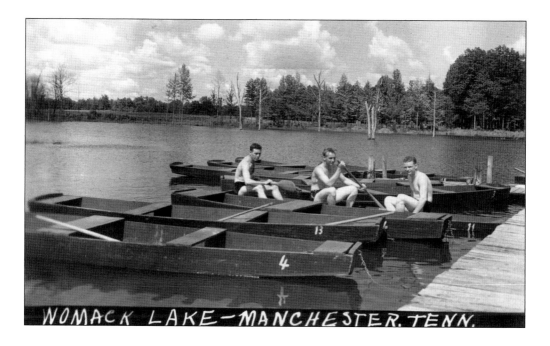

The dam that formed the 40-acre Womack Lake was built in 1938 by Dr. Almon Alonzo Womack. The lake, located four miles north of Manchester, was a center of recreation for the public with fishing and motorboat rides. There was also a motorcycle rodeo in 1939 involving stunts and races. The real–photo postcard from 1942 above shows three unidentified men enjoying the boats, while the real–photo postcard below shows four unidentified young girls fishing from their boat. Womack Lake has been owned by various other people, including Dick Dickens, Paul and Stella Huffman, and Jack and Faye Huffman. (Below, courtesy of Ridley Wills II.)

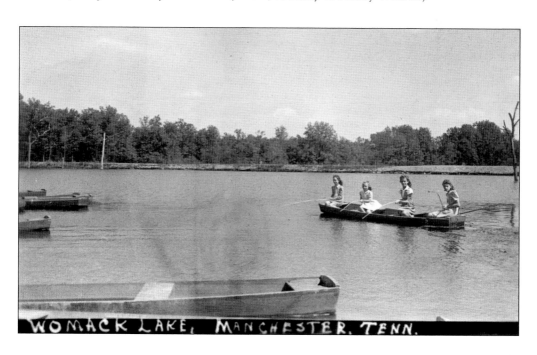

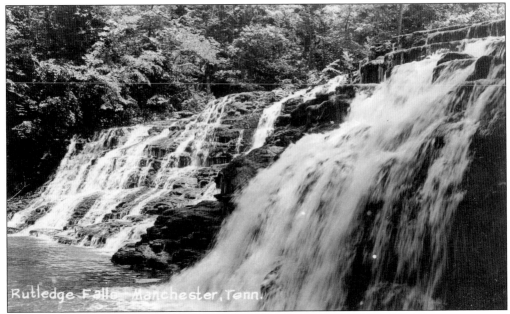

Rutledge Falls Manchester, Tenn.

These two postcards depict Rutledge Falls, which is one of the most beautiful waterfalls in the area. It is composed of three large cascades that are formed from the water that falls from the Highland Rim of Tennessee into the Central Basin. The name "Rutledge" traces back to Edward Rutledge and Arthur Middleton, two signers of the Declaration of Independence who were brothers-in-law. Edward Rutledge purchased large tracts of land in the area, which were later owned by his son Maj. Henry Middleton Rutledge. Various owners of the property include Lytle and Fannie Hickerson, Minnie Hickerson Raht, and Lyndon B. "Pop" Jennings. Jennings salvaged a statue from the Tennessee State Capitol while it was being renovated from 1956 to 1958 to place at the falls.

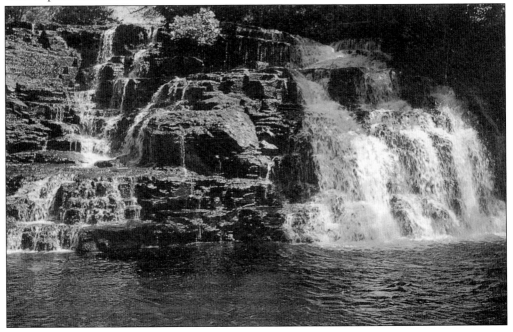

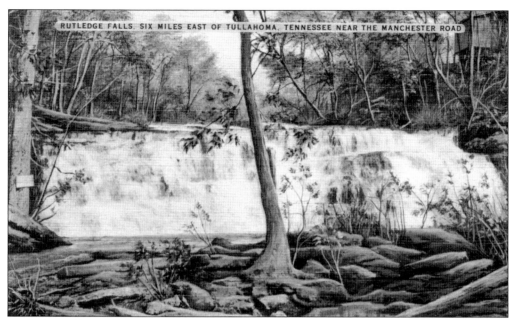

RUTLEDGE FALLS, SIX MILES EAST OF TULLAHOMA, TENNESSEE NEAR THE MANCHESTER ROAD

Rutledge Falls was the backdrop for a scene in *Hannah Montana: The Movie* in which Travis, played by Lucas Till, and Miley, played by Miley Cyrus, swam and picnicked. Manchester is also home to the Hollywood actor Donald Joseph "D.J." Qualls, who has starred in *The New Guy, Hustle & Flow, Road Trip*, and *Cherry Falls* and has appeared in *Supernatural, Scrubs, Lost, CSI, Breaking Bad,* and *The Big Bang Theory*.

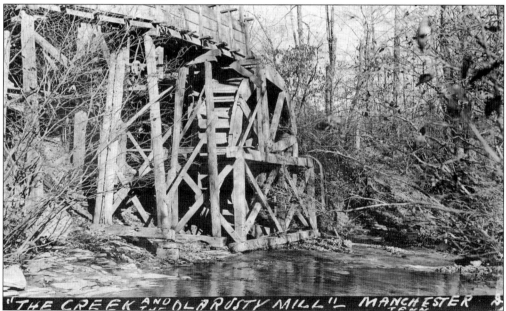

This postcard shows an old mill near Manchester. Some of the old mills nearby included Samuel Brantley's sawmill and gristmill on Noah's Fork, the Beckman brothers' flour mill and gristmill on Noah's Fork, James Howard's corn mill on Bradley Creek, John Bryan's gristmills on Barren Fork of Hickory Creek, L.D. Hickerson Jr.'s sawmill on Haggard's Branch, and James Stephen's gristmill on Goodman's Branch.

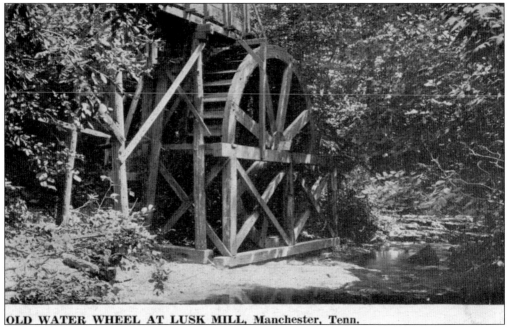

OLD WATER WHEEL AT LUSK MILL, Manchester, Tenn.

The postcard above is of a waterwheel that was located in Blanton's Chapel, sometimes referred to in earlier years as Lusk Mill. The over-shot-type wheel was built on Brewer Creek in the late 1880s by Edmund Lusk, who ran the mill until 1900. The Lusk family operated the mill thereafter except for five years when it was leased to John Tolliver. Edmund Lusk's son Isaac Sherwood Lusk took over operations of the mill and continued until his death in 1926. Isaac's sons William Edmond Lusk and Malcolm Lusk ran the mill into the early 1930s. Marion Lusk, a descendant, later gained ownership of the property. The postcard shown below is of a falls in the Lusk Mill area.

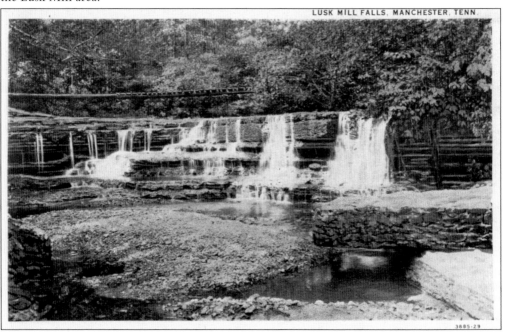

LUSK MILL FALLS, MANCHESTER, TENN.

3885-29

Seven

TOURIST COURTS, HOTELS, AND MOTELS

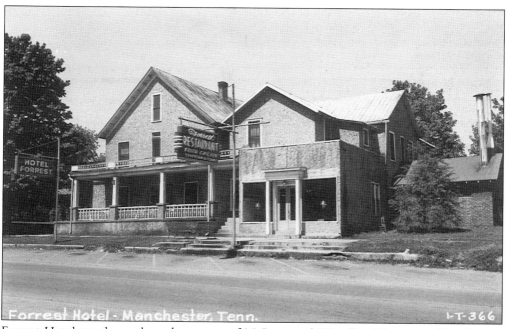

Forrest Hotel was located on the corner of McLean and Woodland Streets in Manchester. Forrest and Cordelia Womack bought the hotel in 1921, when it was known as Manchester Hotel. Thereafter it became known as Hotel Forrest. It had 50 rooms for rent on two stories, two bathrooms on each floor, and a dining room and lobby big enough for banquets. (Courtesy of Jerry D. Yates.)

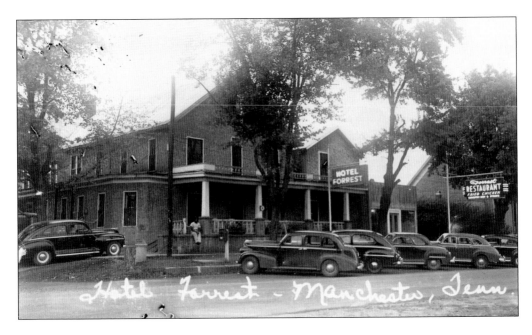

The Forrest Restaurant sported a jukebox and pinball machine. Cordelia Womack, known as "Miss Cordie" to her guests, cooked country hams, steaks, fried chicken, and crackling bread that kept guests coming back for more. It was also a popular place for local dances and banquets. In 1941, Hotel Forrest was a popular place to stay for soldiers of the Tennessee Maneuvers and from nearby Camp Forrest, which was an active Army post between 1940 and 1946. Both operations involved thousands of military, some resident family members, and many visitors. The "no vacancy" sign was lit constantly. Many guests were kept entertained in the lobby by dancing and listening to the piano music. (Below, courtesy of Ruth Banks Morton.)

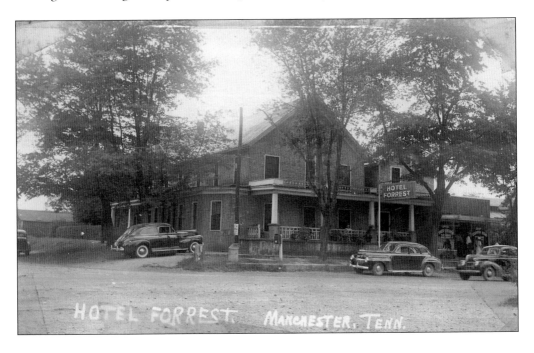

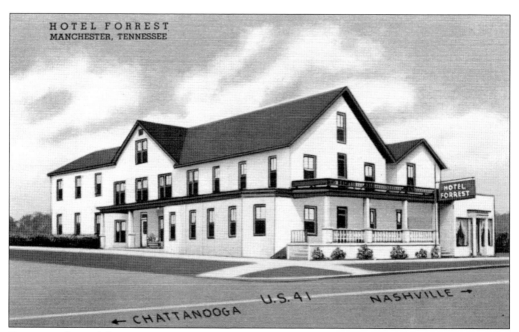

Forrest and Cordelia Womack owned the hotel for 21 years until they sold it to Dave King in 1942. Brown Minor managed the hotel in 1946. The restaurant's cooks at that time included Price Jernigan, Emma Manning, and Orien McBride, who was known as the "steak king." The hotel was eventually torn down in 1968.

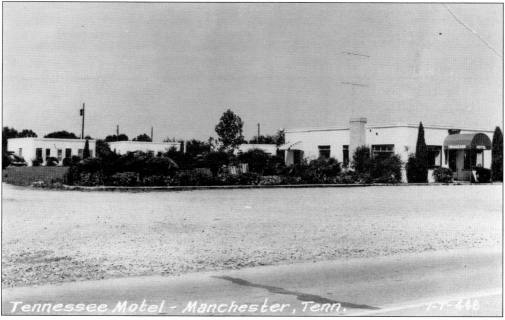

The Tennessee Motel was located on Highway 41, one mile south of Manchester. It was built by Bowlin Morton and Oscar Hill in the late 1930s. Scenes for the 1981 film *The Night the Lights Went Out in Georgia*, starring Dennis Quaid, Kristy McNichol, Mark Hamill, and Don Stroud, were filmed at the Tennessee Motel.

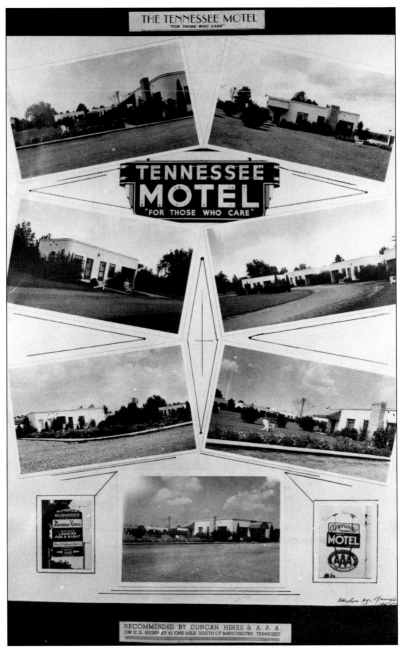

This is a unique multi-view postcard of various photographs taken of the Tennessee Motel in 1948 that depicts a typical tourist court in Manchester in the 1940s. It consisted of nine double cabins, a central coffee shop, and an office building. The buildings were made of blocks. Note the cabins' rounded corners. The motel's lawn was well landscaped with shrubbery, and Adirondack chairs were available for guests to sit and watch traffic on Highway 41 pass by. The sign on the lower left hand side of this postcard shows that the Tennessee Motel prided itself on being recommended by Duncan Hines, author of *Lodging for a Night*. It was also an approved member of the AAA, as seen on the sign on the lower right side of this postcard. This pride was further extended by the motel's motto, "For Those Who Care."

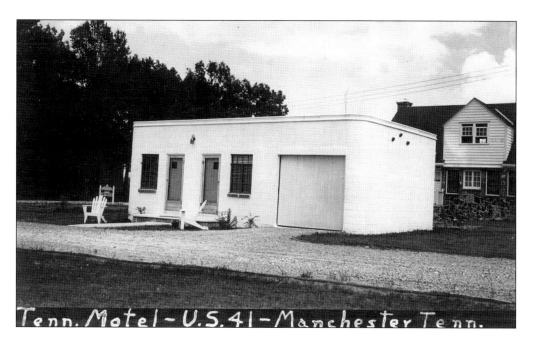

Tenn. Motel – U.S. 41 – Manchester Tenn.

A film crew of about 100 people was in Manchester in late August 1980 filming scenes at the Tennessee Motel and on the square in Manchester. About 27 Manchester residents made the big time as they were selected to appear as extras in the movie. It is about a country singer, played by Dennis Quaid, and his sister, played by Kristy McNichol, who are trying to become successful country music artists in Nashville. Mark Hamill plays a state trooper who falls in love with Kristy McNichol's character. The lyrics from the song "The Night the Lights Went Out in Georgia" by Bobby Russell served as inspiration for the movie.

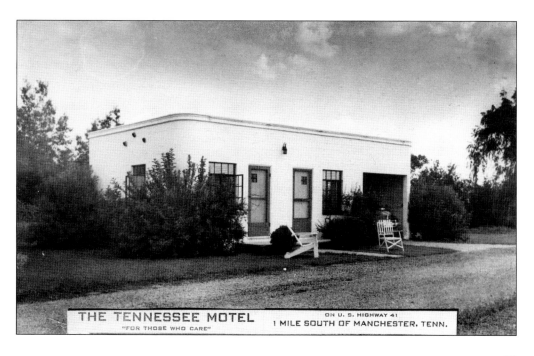

THE TENNESSEE MOTEL
"FOR THOSE WHO CARE"

ON U. S. HIGHWAY 41
1 MILE SOUTH OF MANCHESTER, TENN.

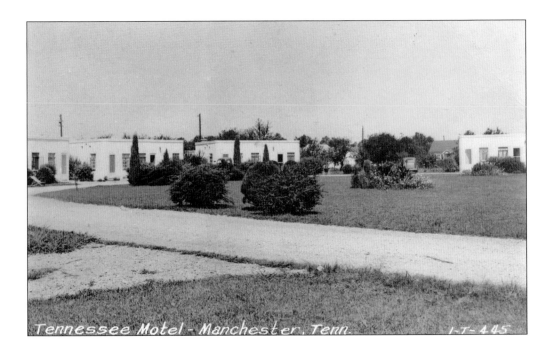

Tennessee Motel - Manchester, Tenn. 1-T-445

The Tennessee Motel was operated by various individuals throughout the years, including Jesse West, Paul Baird, Ernest Bray, and Buck Hannah. Roger Shreffler, who purchased the motel in 1949, also held an important position overseas during his tenure as operator of the motel. He was asked to serve as chief of communications for Gen. Claire Chennault's Civil Air Transport, which was an airline started by Chennault after World War II. The original purpose of the airline was to send relief supplies such as food and medicine into the isolated areas of China.

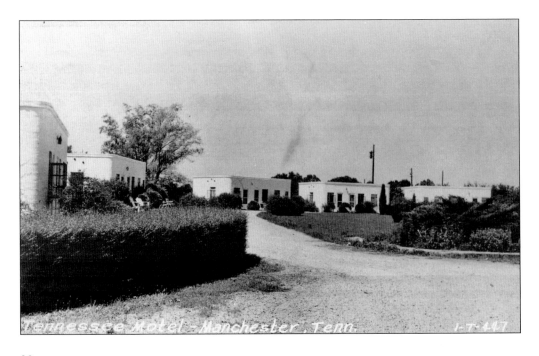

Tennessee Motel - Manchester, Tenn. 1-T-447

There were various other tourist courts around Manchester, including Daniel's Tourist Home, shown above, and Baker's Oak Grove Camp, shown below. The Plainview Tourist Home was located on Highway 41 in Manchester. It was owned by E.G. Daniel in the 1930s. Daniel also served as county trustee from 1928 until 1932. It consisted of the main 12-room residence that was used as a tourist home and sat on 15 acres. There was also an automobile service station and a cafe. Baker's Oak Grove Camp was located two miles north of Manchester on Highway 41. (Above, courtesy of Ridley Wills II.)

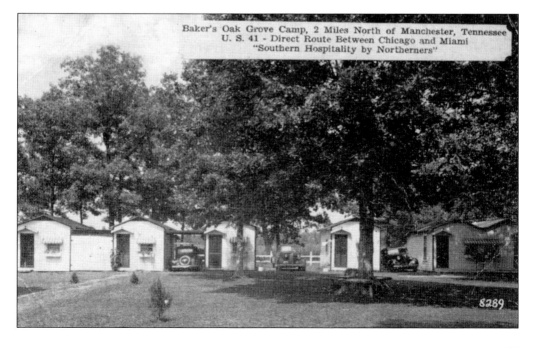

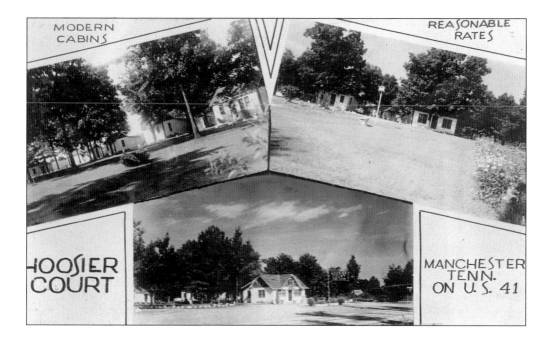

These postcards show photographs of the various buildings at the tourist court named Hoosier Court, which was located about six miles from Manchester on Highway 41. It consisted of 10 cottages, a four-room ranch house, a restaurant, an automobile service station, and a two-room apartment upstairs. This layout with individual cabins surrounded by a landscaped courtyard and a restaurant and service station near the front was typical of the tourist courts along Highway 41 that catered to motorists traveling through Manchester. In 1950, it was owned by Fred Hendrick and John Foster. (Above, courtesy of Billyfrank Morrison.)

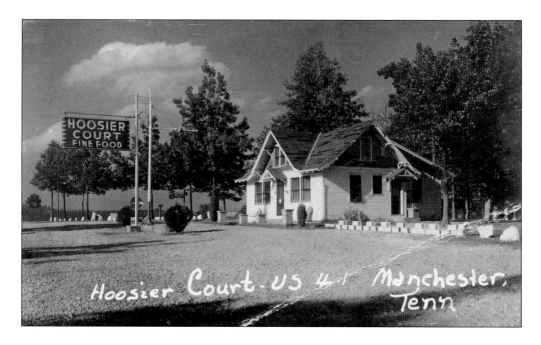

This postcard advertising Hoosier Court was sent in 1952. It reads, "Tonite we are at as postmarked or near there. It is getting hotter as we go further south." Manchester was a common stopping place for travelers along Highway 41 heading from Chicago to Miami or from Miami to Chicago. (Courtesy of Ridley Wills II.)

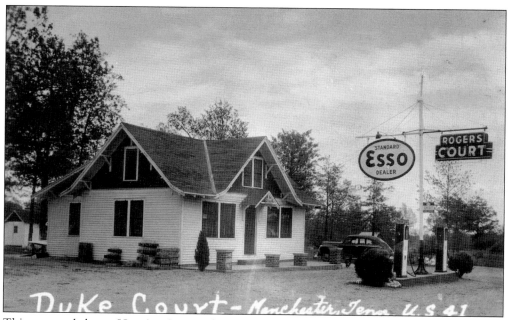

This postcard shows Hoosier Court when it was known as Duke Court. It was operated by Fred Duke. The service station was an Esso dealer. Old bottles can be seen stacked along the side of the station. Note the sign for Rogers Court when the tourist camp was operated by Homer Rogers.

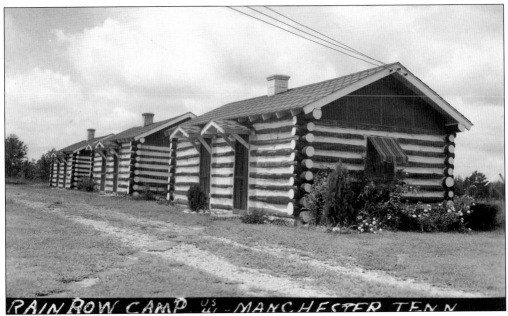

This postcard, originally purchased in 1941, shows the Rainbow Tourist Camp, which was constructed by Herman and Myrtle Cunningham on Hillsboro Road across from the site of the old county fairgrounds. It initially consisted of six double cabins in a log cabin style providing 12 available rooms for rent. (Courtesy of Ridley Wills II.)

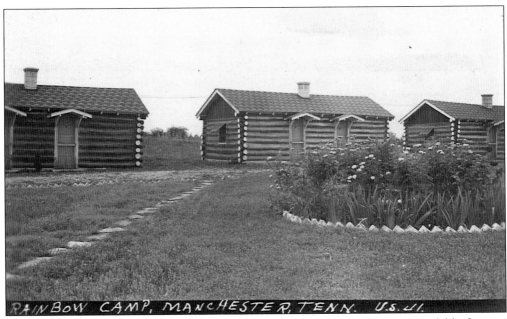

This postcard shows another view of the Rainbow Tourist Camp's cabins available for rent along with their landscaping. This was a pleasant place to stay amongst Highway 41 travelers as evidenced by this postcard, sent in 1941, which reads, "Have had a dandy time. The weather has been wonderful. First warm day." (Courtesy of Pete Jackson.)

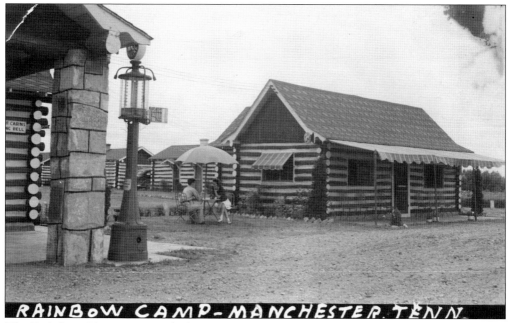

The Rainbow Tourist Camp had a tearoom operated by W.H. Young. There was also an automobile service station, as seen on the left side of this postcard from 1940. The small sign on the pump shows the cost of gas was 16¢ plus 8¢ for tax.

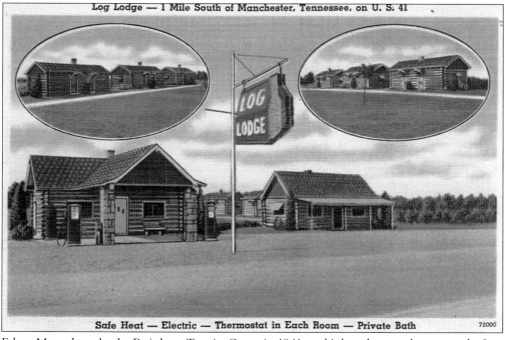

Edgar Myers bought the Rainbow Tourist Camp in 1941, and it later became known as the Log Lodge. The modern cabins had electric heat, private baths, and innerspring mattresses. The automobile service station later had two Erie gas pumps, an Erie air compressor, a kerosene pump, and four 1,000-gallon Birmingham tanks. (Courtesy of CC/M/T Museum, Inc.)

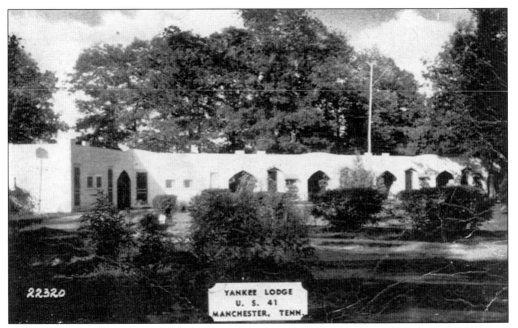

The Yankee Lodge was located on Highway 41, two miles north of Manchester. In the 1940s, it was operated by C.S. Baker. It consisted of 10 cabins, living quarters, and an automobile service station. The cabins had hardwood floors, maple and walnut furniture, and inside communication systems. (Courtesy of Debbie Stribling.)

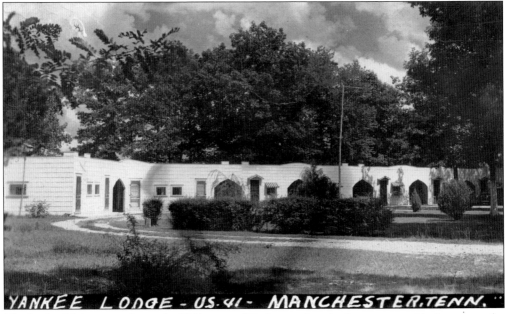

The back of this postcard, sent in 1941, states, "Going to sleep in the cottage with the x over the top. We will drive on down to Chattanooga tomorrow morning just 76 miles." This is a typical example of Manchester being a welcome stop before heading over the treacherous Monteagle Mountain before arriving in Chattanooga.

104

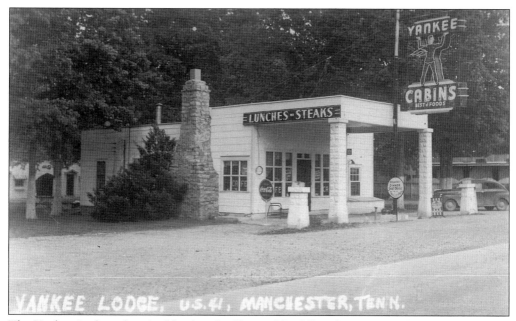

The Yankee Lodge advertised having the "best of foods" with its eye-catching neon sign of a man whose arm flashed up and down. Another sign reads "Breakfast, dinner, short order, trailer park," and others advertise for Coca-Cola and ice cream. The message on this postcard, sent in 1950, describes the lodge's atmosphere, saying, "The spring flowers are in bloom and the frogs are hollering." (Courtesy of Ridley Wills II.)

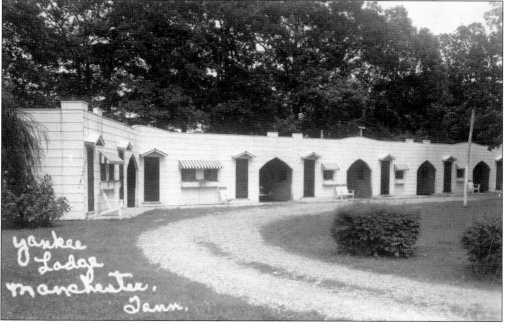

This postcard, sent in 1949, reads, "Dear friends, this is back part of the place. We bought it in July. We had 10 cabins and three room house, restored gas station, sold beer also." In the 1950s, the restaurant was cut away and the gasoline pumps were removed at Yankee Lodge as Highway 41 was widened.

White Plaza Court was located one and a half miles north of Manchester on US Highway 41. By the late 1940s, there were 15 cottages consisting of 40 beds, a seven-room residence, a linen house, an office building, and a service station with coffee shop. Today, only the main residence, seen at the top of this multi-view postcard, remains. (Courtesy of Pete Jackson.)

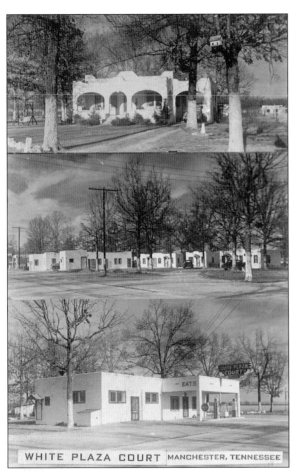

The buildings of the White Plaza Court were located on a 10-acre plot and were built of concrete block and stucco construction. The grounds consisted of lots of shade, an orchard, a grape arbor, and kitchen houses. Well water was supplied by an electric pump to all of the buildings.

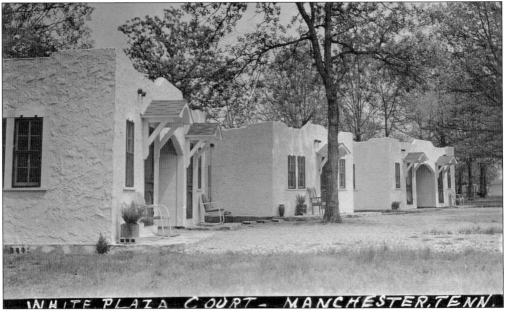

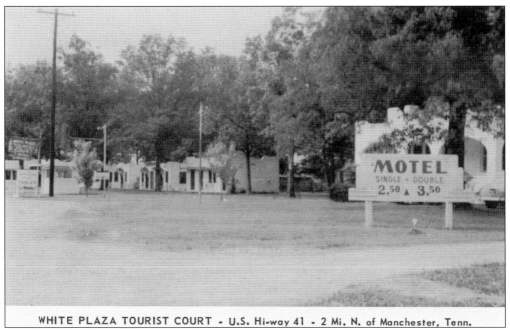

WHITE PLAZA TOURIST COURT - U.S. Hi-way 41 - 2 Mi. N. of Manchester, Tenn.

White Plaza Court was also a popular place to stop and eat amongst Highway 41 travelers. There was a restaurant and clubhouse, which was 30 by 50 feet, with a modern kitchen, a large dining room, and a private dining room. In 1947, Horace Ogles and Travis Little were managers of the café, and Glenn Hickerson was the cook. (Courtesy of Ridley Wills II.)

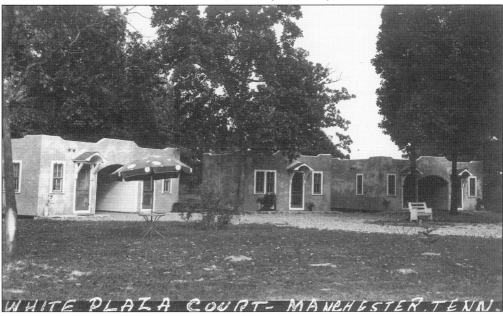

WHITE PLAZA COURT- MANCHESTER, TENN.

White Plaza Court was owned by E.E. Henley and Bowlin Morton and operated by Brown Minor in 1949. It was operated by Hubert Fisher in 1952. This postcard, sent in 1941, shows some of the cottages. It reads, "We had lunch at place on card, very nice; came through the beautiful Tennessee Mountains today, 270 miles so I am weary but alright." (Courtesy of Ridley Wills II.)

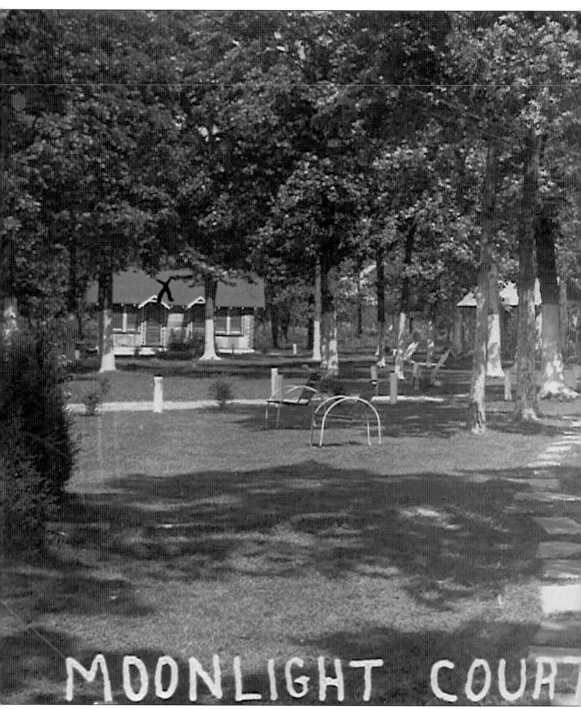

MOONLIGHT COUR

Moonlight Court was a tourist court located four miles north of Manchester on Highway 41. Roy Harris was the owner in the early 1950s. This postcard shows the facade of the brick home residence, landscaping, and some of the cottages at Moonlight Court. Note the flamingo lawn ornaments and reclining chairs, lending a unique resort-like atmosphere to the lawn. Tourist courts such as this in Manchester afforded a pleasant place to stay for weary Highway 41 travelers.

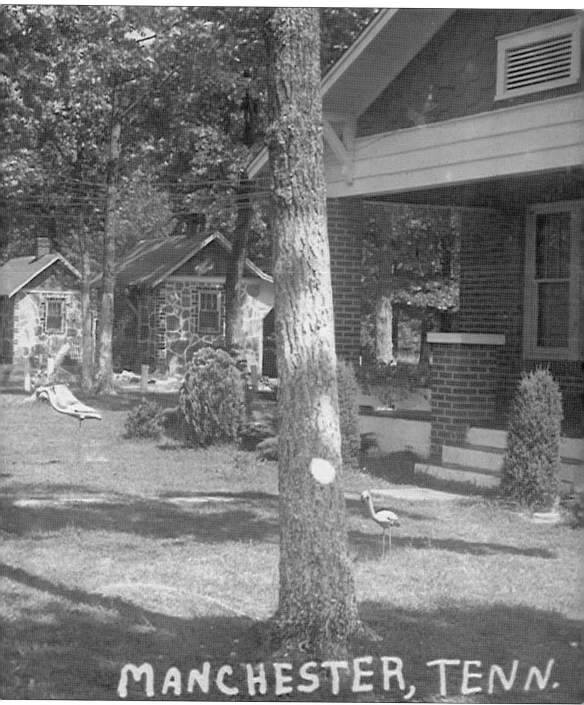

MANCHESTER, TENN.

The sender of this postcard stayed in the double cottage shown in this view of Moonlight Court. This postcard, sent in 1949, states, "We are in this double cottage for the night. 447 mi. The first six hours were like glass. Saw lots of wrecks. So thankful to get out of it." (Courtesy of Pete Jackson.)

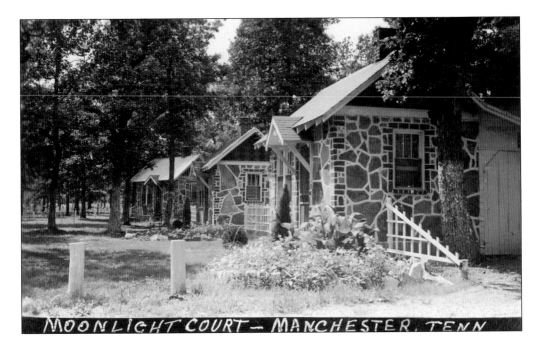

Moonlight Court had five double and three single cottages. The Crab Orchard stone used in the construction of these cottages gave Moonlight Court a unique look amongst the local tourist courts, as depicted in these real-photo postcards. This special type of sandstone, also known as Crossville sandstone, is known for its durability and colorful appearance. It was named after the city of Crab Orchard, Tennessee, on the Cumberland Plateau, which is located in the Crab Orchard Mountains. Crab Orchard stone is regional to this area and found only in the Cumberland Plateau. Three of these cabins still stand along Highway 41.

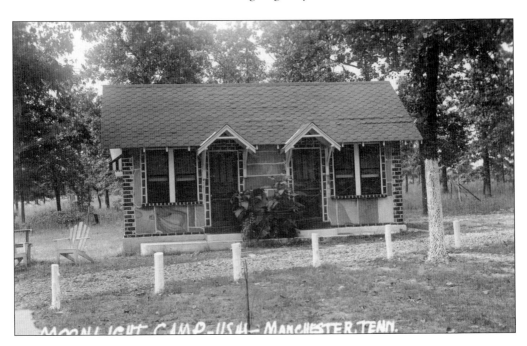

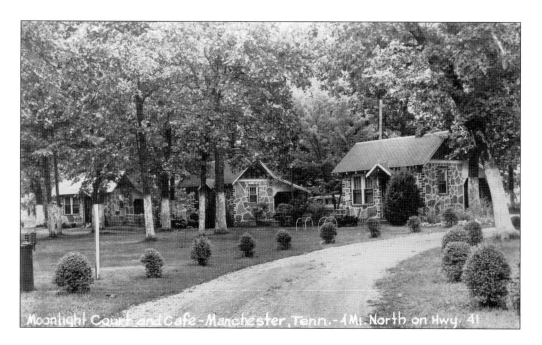

Moonlight Court and Cafe - Manchester, Tenn. - 4 Mi. North on Hwy. 41

These postcards of Moonlight Court depict some of the cottages' modern conveniences and natural surroundings at this tourist court. The postcard above depicts several of the cottages facing a courtyard that was landscaped beautifully with shade trees, shrubbery, and a stone barbeque pit. The cottages, as seen in both postcards, were modern at the time, as they each had connecting garages, baths, and hot and cold running water and were also heated. Many of the tree trunks depicted in these postcards were painted white, a common practice at the time to protect the trees from damaging insects and sunscald.

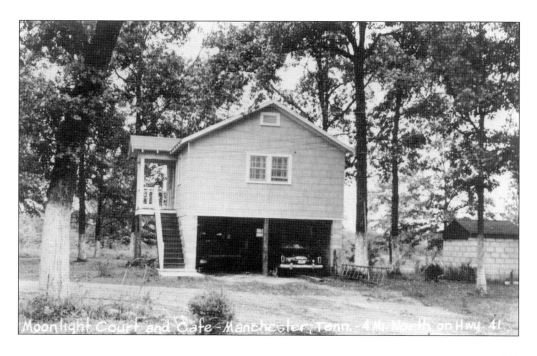

Moonlight Court and Cafe - Manchester, Tenn. - 4 Mi. North on Hwy. 41

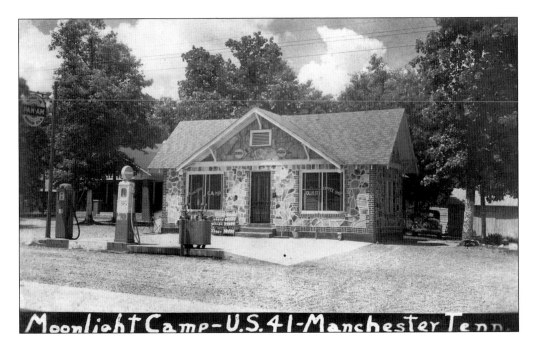

These postcards show the café and automobile service station at Moonlight Court. The windows in the postcard above read, "Moonlight Camp, Quality Coffee Shop." There are racks of motor oil cans outside. Signs for Pan Am gasoline can be seen in both of these postcards. Many of these tourist courts catered not only to overnight guests, but also travelers stopping in for a quick bite to eat and to fill their tanks and change oil as they traveled down Highway 41. According to Ruth Banks Morton, the café at Moonlight Court was also a popular place amongst the young dating crowd. (Above, courtesy of Ridley Wills II.)

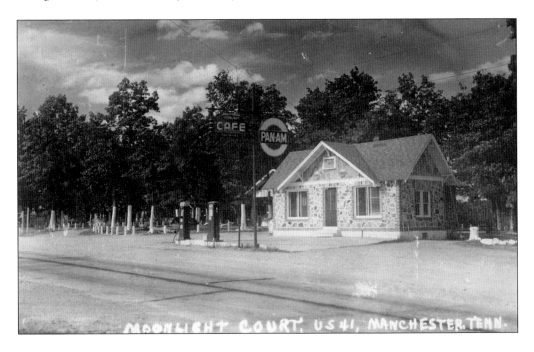

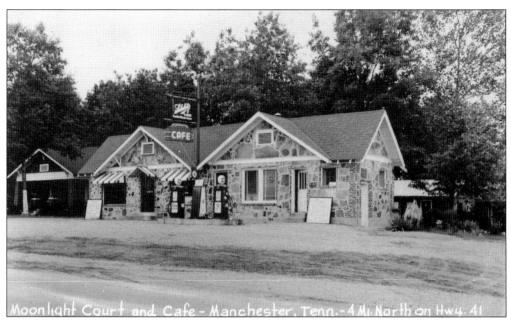

This postcard depicts a larger café and filling station at Moonlight Court. The menu signs out front advertise home-cooked meals. Other signs advertise "Schlitz, the beer that made Milwaukee famous" and "51 Beer." Pan Am torch globes top the gas pumps, and Pan Am advertising globes adorn the building.

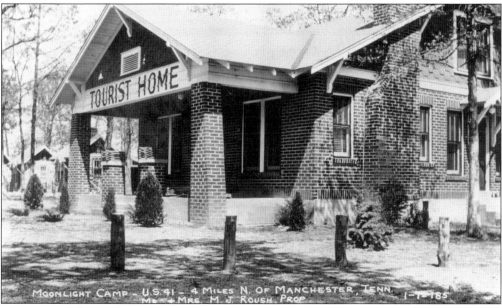

This postcard shows the nine-room brick home residence associated with Moonlight Court. The residence included hardwood floors, a modern bath, butane gas, hot and cold running water, electrical wiring for appliances, a big front porch, and a large fireplace. The residence and tourist court were surrounded by 42 acres of land. (Courtesy of Lisa Ramsay.)

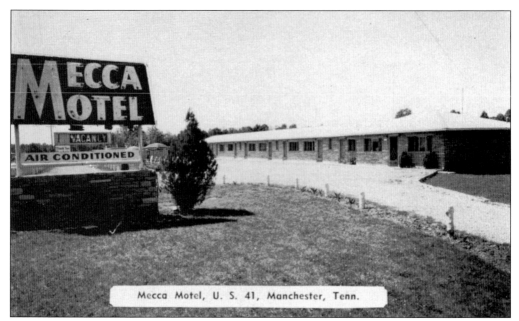

Mecca Motel, U. S. 41, Manchester, Tenn.

The Mecca Motel, located one and a half miles south of Manchester at Red Hill on Highway 41, was opened in 1952 by R.C. Bailey. It was built by Bailey, who was a graduate of the Lewis Hotel Training School in Washington, DC. The six-room motel and family living quarters were constructed of Crab Orchard stone. It was later owned and operated by Harold and Betty Jones.

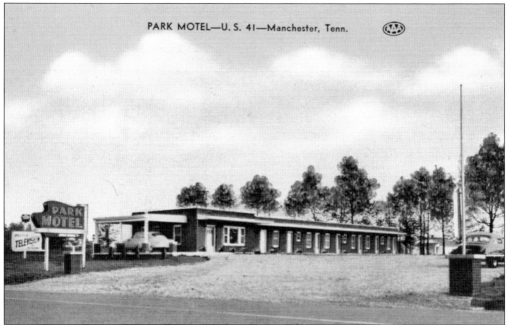

PARK MOTEL—U. S. 41—Manchester, Tenn.

The Park Motel, located at 1504 Hillsboro Highway in Manchester, opened in 1952 and was owned and operated by Baker Bass and Laura Bell. The motel shown in this postcard was later expanded to consist of additional units and modern amenities, including Mengel furniture. The Park Motel is still in business today.

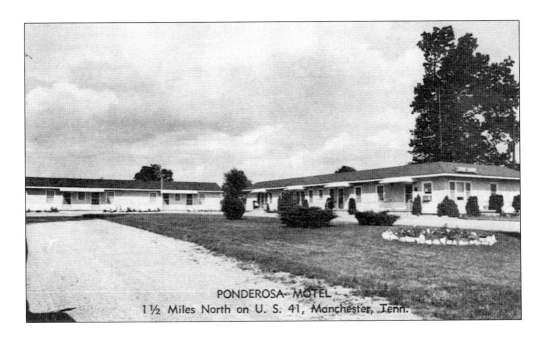

PONDEROSA MOTEL
1½ Miles North on U. S. 41, Manchester, Tenn.

The Ponderosa Motel was located two miles north of Manchester on Highway 41 and completed by Jimmie Walker in 1952. It was owned by Muriel Vaughn in 1954. It consisted of six units and a four-room living quarters. The rooms were air-conditioned, electrically heated, and modernly furnished. The grounds consisted of two and a half acres. The walls of the Ponderosa Motel were constructed of ponderosa pine paneling that gave the motel its uniqueness and served as the inspiration for its name. This type of wall paneling was popular in the 1950s for its decorative appearance. (Above, courtesy of Pete Jackson.)

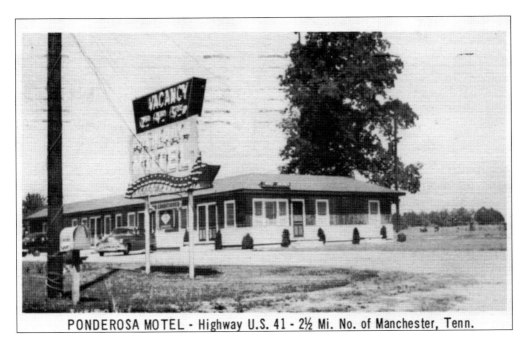

PONDEROSA MOTEL - Highway U.S. 41 - 2½ Mi. No. of Manchester, Tenn.

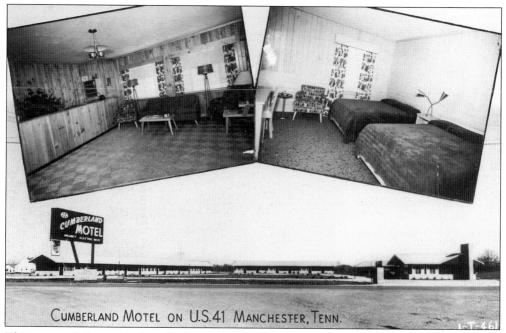

CUMBERLAND MOTEL ON U.S. 41 MANCHESTER, TENN.

This postcard shows the Cumberland Motel, which was located on Highway 41 on the old county fairgrounds, now the site of the Peoples Bank and Trust. This postcard, sent in 1953, gives a high review of Manchester motels, as it reads, "We stayed over in this place the second night. Those motels are really super." (Courtesy of Ridley Wills II.)

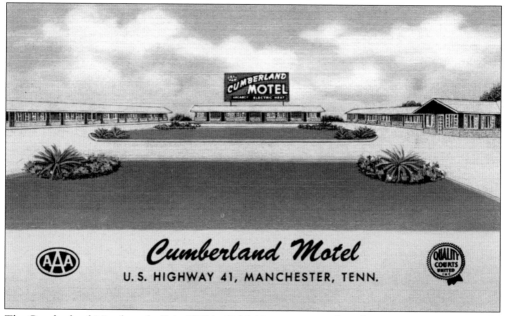

Cumberland Motel
U. S. HIGHWAY 41, MANCHESTER, TENN.

The Cumberland Motel was built in 1952 by E.M. Newman. Motels such as this catered to motorists with numerous rooms and modern conveniences. Before building the motel, Newman owned a sawmill in nearby Belmont from which he exported lumber to Europe. He also constructed several other business buildings and residences in Manchester, including some of the Riverhill and Woodland homes.

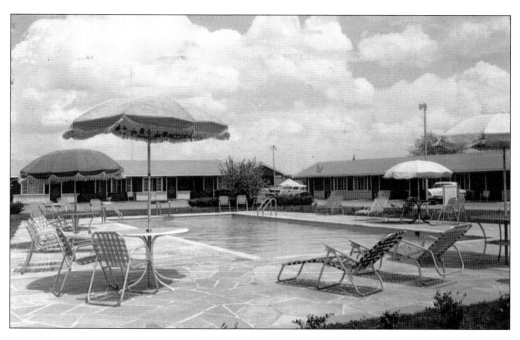

The operators of the Cumberland Motel have included Edward Culpepper, Verlon and Irene Freeze, and Charles Cravens. Adjoining the Cumberland Motel was the Glass House Restaurant, operated by various individuals, including Orien and Elizabeth McBride and Felix Sowell. The restaurant served Southern dishes, including country ham and fried chicken. The motel eventually had a heated swimming pool, as shown in the postcard above, sent in 1964. The sign in front of the motel in the postcard shown below reads, "Our Pool is Cool." The exterior had a beautifully landscaped lawn and shuffleboard. It also advertised as having walking horses available nearby for the enjoyment of guests.

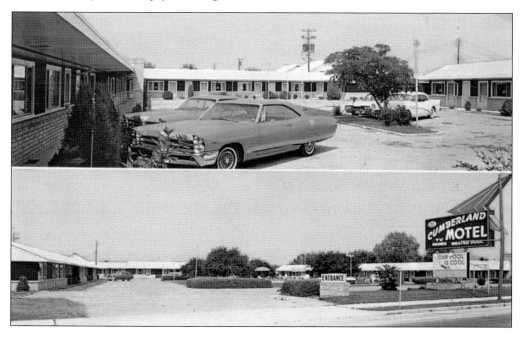

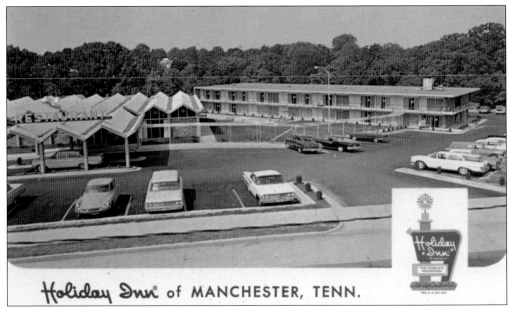

Holiday Inn® of MANCHESTER, TENN.

The first Holiday Inn in Manchester was built and owned in the early 1960s by Joe Powell Shelton and Dr. Clarence Farrar. In the 1960s, Walter Thomas "T" Richardson and his wife, Nell, managed the hotel's restaurant. The hotel was later known as Manchester Motel and is presently known as the Greenleafe Inn. The second Holiday Inn was built in the late 1970s at Interstate 24 and Highway 41.

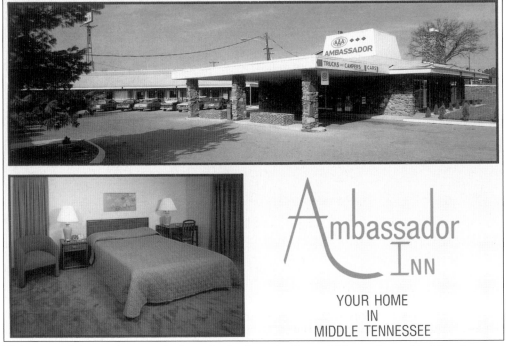

This postcard shows photographs from the Ambassador Inn, which was located in Manchester at Exit 110 off Interstate 24. It was managed at one time by Jim Tyler. The present-day Ambassador Inn and Luxury Suites is a two-story building at the same exit. (Courtesy of Ridley Wills II.)

Eight

MISCELLANEOUS

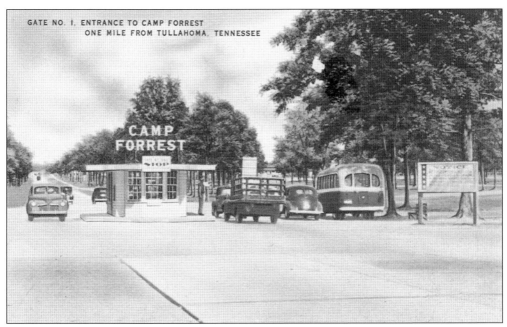

GATE NO. 1, ENTRANCE TO CAMP FORREST
ONE MILE FROM TULLAHOMA, TENNESSEE

During World War II, Camp Forrest served as an induction center, a basic training facility, a prisoner of war camp, and a training site set up by Vanderbilt for medics and the corps of nurses. Approximately 250,000 men received their physical examinations here. Many soldiers also received their basic training here. The facility was declared surplus in 1946 and was torn down. (Courtesy of Arrowheads to Aerospace Museum.)

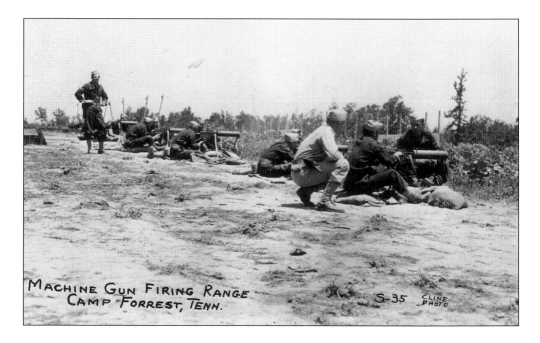

These two real-photo postcards by Walter M. Cline show soldiers in action while training at Camp Forrest. The postcard above shows soldiers at the firing range at Camp Forrest training with machine guns. The postcard below shows soldiers on the parade grounds. Troops were trained from September 1941 until March 1944 in infantry, engineering, artillery, and signal groups. The camp was comprised of about 85,000 acres, providing a large training ground. William Northern Field was built by the Army Air Forces in 1942 and became an air training base for the crews of B-24 bombers. (Both, courtesy of Ridley Wills II.)

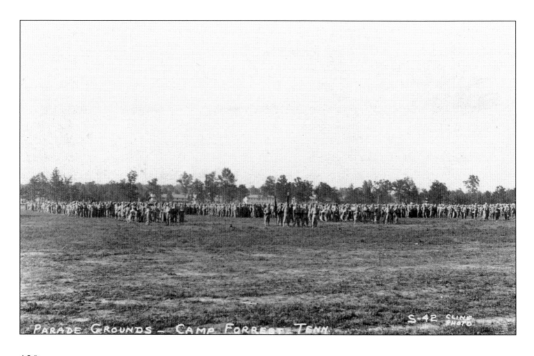

Camp Forrest became a prisoner of war camp on May 12, 1942, with more than 24,000 prisoners of war. The German POWs became laborers and could be picked up by local landowners to be used for the day. The hospital at Camp Forrest, shown in the postcard above, became a general hospital for the prisoners of war, which was one of only two such hospitals in the United States. The postcard below shows one of the four theaters at Camp Forrest. After the camp closed, some area homes were built of wood from the barracks and other buildings that were torn down.

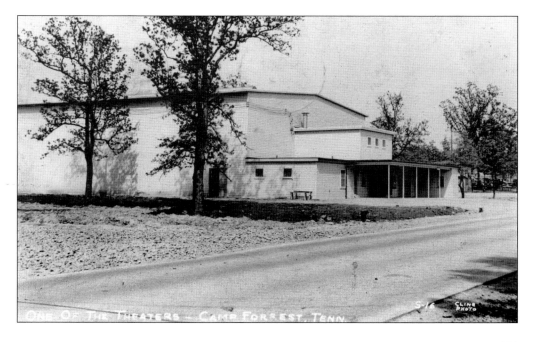

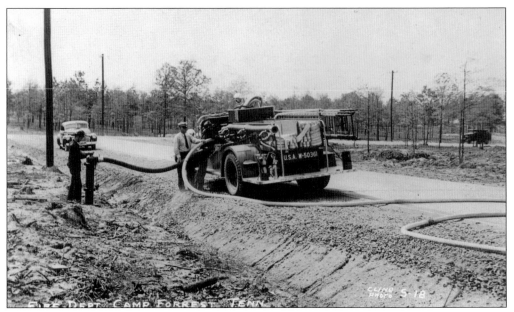

This real-photo postcard by Cline shows a fire truck at Camp Forrest. The truck is identified on the back as USA W-50361. Fire trucks were in need at Camp Forrest due to the air training field and the fact that it was the fifth largest city in Tennessee at the time.

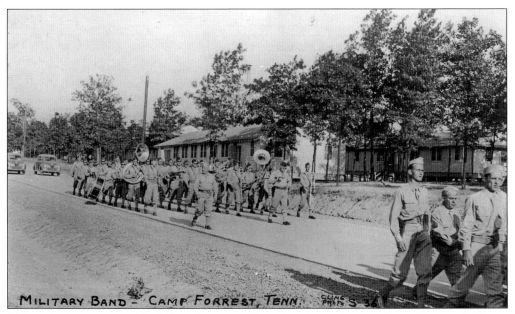

This real-photo postcard by Cline shows a military band marching at Camp Forrest. Military bands trained here with infantry regiments. They trained and played at all important military functions. Many band members were sent overseas during the war; thus, being a soldier was their top priority. (Courtesy of Ridley Wills II.)

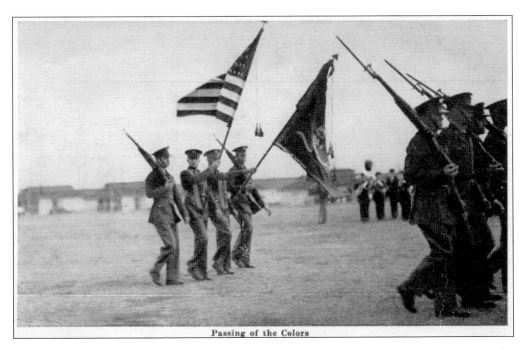

Passing of the Colors

The real-photo postcard above of the passing of the colors at Camp Forrest, sent in 1943 by Pvt. Richard Linehan to the Bonner family in Shelbyville, Tennessee, reads, as shown below, "Dear Folks, Thanks again for your kindness while we were at your home. The food was the best any of us had eaten since we left home. And your extra comfortable bed did the trick. I am the smallest of the boys. Thanks again." Many of the soldiers stationed at Camp Forrest found comfort at homes in and around Manchester. Many relationships were developed and continued throughout the war through letters sent to these soldiers abroad.

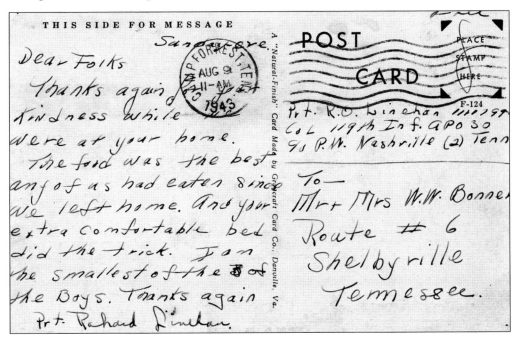

Mountain Laurel Manchester, Tenn. I-T-368

Dogwood Tree In Full Bloom - Manchester, Tenn. I-T-369

The mountain laurel and the dogwood tree are just two of many flowering beauties that have always graced the Manchester area. The town also has the May Prairie located three miles south of town just off Highway 41. It is a 250-acre natural area consisting of plants that are rare in Tennessee due to the state's wetter conditions. Many of these plants are found only in the drier western prairie states. Some of the plants include snowy orchids, big bluestem, Indian grass, switch grass, plume grass, Indian paintbrush, false indigo, bluets, southern dock sunflowers, blazing star sunflowers, and false asphodels. (Above, courtesy of Lisa Ramsay.)

These novelty postcards were sent to Clemmie Huffman in Hillsboro. The Valentine's Day postcard shown above was postmarked on February 8, 1921. The message reads: "You may not believe it but it's true." The postcard shown below was postmarked on January 20, 1920. Obviously, the sender was stuck on Clemmie. In the early 1900s, it was popular to send holiday-themed postcards. Holidays such as Valentine's Day, Easter, Halloween, and Christmas were commemorated in these cards. Valentine's cards such as these were popular ways for a beau to express his love for his lady. (Both, courtesy of CC/M/T Museum, Inc.)

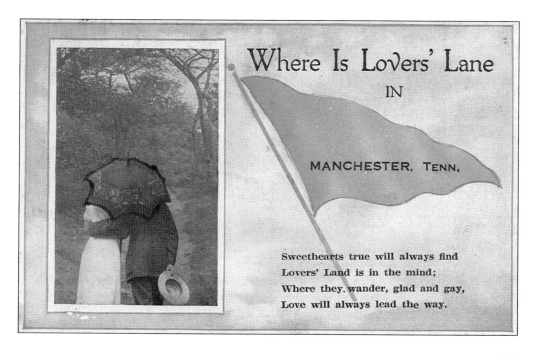

KSI-8582

"TENNESSEE FISHERMAN & LADY FISHERMAN"
UNIT 89

73's 88's

"VIRGINIAN"
DAVID

ELMER & LOTTIE GREEN
Rt. 6 Box 658
Manchester, Tenn. 37355

The citizen's band communications members in Manchester are creative and communicative, as shown by the postcards, known as QSL cards, that they shared with each other. These cards were sent as a confirmation that a signal was heard by the sender of the postcard to the operator. Above is the fishing-themed QSL postcard sent by Elmer and Lottie Green, known as the "Tennessee Fisherman" and "Lady Fisherman." Some of the other known members around Manchester who had similar postcards were Hal Wrede, known as "Red Builder;" Jim and Diane Alexander, known as "Lucky Strike" and "Lucky Lady;" Karyn Fulton; "Raider;" "Sandman;" and "Flatfoot." Marvin Lawley III of Manchester was president of the Middle Tennessee Radio Amateur Society in 1980. Jack Lawley and Helen Abernathy of Manchester and Virginia Lane of Hillsboro were members of the society. (Courtesy of Billyfrank Morrison.)

BIBLIOGRAPHY

Bridgewater, Betty Anderson. "A Hundred Years Strong and Still Going Strong or A Look at the Coffee County Courthouse." *Coffee County Historical Quarterly 2*, issue 4 (Winter 1971): 1–17.

Coffee County Heritage Book Committee. *History of Coffee County, 1836–2004*. Marceline, MO: Walsworth Publishing, Inc., 2005.

Crane, Sophie and Paul. *Tennessee Taproots: Courthouses of Tennessee*. Franklin, TN: Hillsboro Press, 1996.

Ewell, Leighton. *History of Coffee County Tennessee*. Manchester, TN: Doak Printing Co., 1936.

Manchester Times. Weekly newspaper. Manchester, TN, January 1902–December 1980.

Martinez, Corinne. *Coffee County from Arrowheads to Rockets*. Tullahoma, TN: Coffee County Conservation Board, 1969.

"May Prairie Class II Natural-Scientific State Natural Area." Tennessee Department of Environment and Conservation. http://www.tn.gov/environment/natural-areas/natural-areas/may (accessed September 25, 2013).

McMahan, Basil B. *Coffee County, TN Then and Now*. Nashville, TN: Williams Printing, 1983.

Morton, Ruth Banks. *A Life Remembered*. Punta Gorda, FL: Corporacion Euanitos, S.A., 2004.

Old Stone Fort State Archaeological Park Interpretive Path Guide. Nashville, TN: Tennessee Department of Environment and Development, June 2010.

Reeves, Reggie. "The Duck River: Tennessee's Newest Designated State Scenic River." Tennessee Department of Environment and Conservation. http://www.tn.gov/environment/conservatist/archive/duckriver.htm (accessed September 25, 2013).

Tullahoma News and Manchester Times. A Pictorial History of Coffee County Tennessee. Marceline, MO: Heritage House Publishing, 1999.

West, Carroll Van. *The Tennessee Encyclopedia of History and Culture*. Knoxville, TN: UT Press, 1998. Revised edition available at http://tennesseeencyclopedia.net/

West, Judy F., PhD. *Manchester, Coffee County, Tennessee: A Business and Community Pictorial Heritage*. Manchester, TN: Manchester Chamber of Commerce, 1986.

Winters, Linda. *Cemeteries and Tombstone Inscriptions of Coffee County, Tennessee*. Vol. 1 and 2. Summitville, TN: Linda Winters, 2007.

Discover Thousands of Local History Books Featuring Millions of Vintage Images

Arcadia Publishing, the leading local history publisher in the United States, is committed to making history accessible and meaningful through publishing books that celebrate and preserve the heritage of America's people and places.

Find more books like this at
www.arcadiapublishing.com

Search for your hometown history, your old stomping grounds, and even your favorite sports team.

Consistent with our mission to preserve history on a local level, this book was printed in South Carolina on American-made paper and manufactured entirely in the United States. Products carrying the accredited Forest Stewardship Council (FSC) label are printed on 100 percent FSC-certified paper.